IMAGES
of America

MUKILTEO

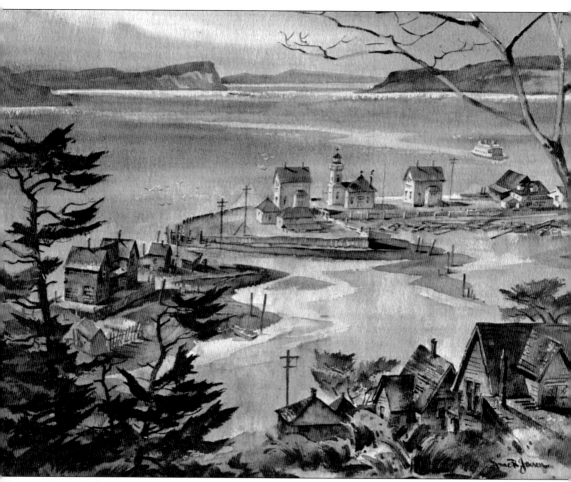

Arne R. Jensen, a resident of Everett, Washington, was born in 1906. He first studied at the Chicago Art Institute and later at the Seattle Art Institute. Jensen was a member of the Northwest Watercolor Society, the American Watercolor Society, and the Puget Sound Group of Northwest Painters. He began exhibiting his work in the Northwest in 1932. His art hangs in homes, businesses, and museum collections throughout the country. He died in 1993. This picture is a painting by Jensen entitled *Early Mukilteo*. (Courtesy of Sno-Isle Regional Libraries.)

ON THE COVER: This late-1890s photograph shows elementary schoolchildren posing with the American flag as a backdrop. The picture was taken at Rose Hill School in Mukilteo, Washington. (Courtesy of the Mukilteo Historical Society.)

IMAGES
of America

MUKILTEO

Steve K. Bertrand

ARCADIA
PUBLISHING

Copyright © 2011 by Steve K. Bertrand
ISBN 978-0-7385-7421-9

Published by Arcadia Publishing
Charleston, South Carolina

Printed in the United States of America

Library of Congress Control Number: 2010935858

For all general information, please contact Arcadia Publishing:
Telephone 843-853-2070
Fax 843-853-0044
E-mail sales@arcadiapublishing.com
For customer service and orders:
Toll-Free 1-888-313-2665

Visit us on the Internet at www.arcadiapublishing.com

For the Mukilteo Historical Society and the people of Mukilteo, past and present, who have made this place such a "good camping ground"

CONTENTS

ACKNOWLEDGMENTS

I would like to express my deepest gratitude to the numerous individuals who have shared their wonderful stories and/or contributed historical images for this book. The generosity extended is much appreciated. This project represents a community effort. Without their assistance, this depiction of Mukilteo would not be possible.

I wish to thank Ann and John Collier of the Mukilteo Historical Society, David Dilgard and Melinda Van Wingen of the Northwest History Room of Everett Public Library; Barbara George of the Snohomish County Museum of History; Carolyn Marr of the Museum of History and Industry; Nicolette Bromberg of the University of Washington Libraries Special Collection; Marcia O'Hair of the Snohomish Historical Society; Jane Crawford of the Sno-Isle Regional Libraries; Catherine D'Ambrosia of the Port of Everett; Fred Poyner and Joy Werlink of the Washington State Historical Society; Elaine Garcia of the Everett School District; Mary Hammer of the Department of Transportation; Scott Kraft of Northwestern University Chicago; Nick Henderson of the Roslyn Historical Society; Lita Sheldon of the Tulalip tribes; Theresa Trebon of the Swinomish tribe; Rebecca Carr, Sara Bruestle, and Caitlin Archipley of the Beacon; Caitlin Kelly of the Edmonds Historical Society and Museum; Jennifer Berner of the City of Mukilteo; Ed Martin of the Pacific Hydrographic Branch; Richard Sullivan of the Everett Maritime Museum; Kay Scheller of The Hogland House; Bob Donegan of Ivar's Restaurant; and Bob Maphet of the Diamond Knot Brewery.

In addition, I would like to thank my wife, Donna Marie Bertrand; my parents, Dan and Jeanette Bertrand; my niece Audrey Dannar; Opal McConnell; Christopher Summit; Ed Morrow; Marie (Josh) Kaiser; Beverly (Dudder) Ellis; Tude Richter; Marty Eidbo; Pat Kessler; Daren Hopper; William Hull; Paul Reynolds; Mas Odoi; Steve Mayo; Debbie McGehee; Richard Emery; Dave Larson; Madeline (LeBeau) Kuykendall; Renee Ripley; Jack and Larry O'Donnell; Ed and Tim Taylor; Trudy Tobiason; John Cooper; Joy and Katherine Webber; Rick Hawthorne; John Zuanich; Jamie Jensen; Max Minnich; Art Losvar; Vicki Derks; Col. Reymond W. Coffey; Thelma (Weers) Kane; and Mayor Joe Marine for their time, efforts, and expertise.

INTRODUCTION

The history of Mukilteo, Washington, runs as long and deep as its gulches. Early Native Americans dwelling in the Northwest referred to Muk-wil-teo or Buk-wil-tee-whu as "narrow passage" or "to swallow," due to the odd shape of the spit of land where they gathered. This seems to be the closest approximation using the Snohomish dialect of Lushootseed. Though it has come to mean "good camping ground", Chief William Shelton of the Tulalip tribes suggests it means "a neck, throat, or narrowing in a body of water." On May 30, 1792, British explorer George Vancouver anchored his ship *Discovery* at the site that became Mukilteo. He took measurements, gathered botanical specimens, and christened the area as Rose Point after the many wild roses inhabiting the region.

U.S. Navy Lt. Charles Wilkes gave Rose Point the name Point Elliott on American charts, in honor of midshipman Samuel Elliott, during the summer of 1841. The name stuck. Point Elliott continues to be used to the present day.

January 22, 1855, territorial governor Isaac Stevens met on Point Elliott with 82 Native American leaders, including Chief Seattle. A treaty was signed, ceding their lands to the U.S. government in exchange for relocation on reservations, cash, and fishing and hunting rights. It was known as the Point Elliott Treaty or Treaty of 1855. This would result in disputes with the various tribes. As a result, the treaty wasn't ratified until 1859. The Marcus Whitman Chapter of the Daughters of the American Revolution (DAR) dedicated a monument commemorating the treaty on May 2, 1931.

The first white settlement was established in Mukilteo in 1860. Its founders were Morris Frost (1804–1882) and Jacob Fowler (1837–1892). They saw great economic potential for Point Elliott. Mukilteo quickly became known as a city of firsts.

The first pro tem county seat was established January 14, 1861. The first commissioners' meeting soon followed. The first post office was founded July 5, 1861. Jacob Fowler was chosen the first postmaster. He began referring to the settlement by its Indian name, Mukilteo.

Other early business ventures included Eagle Brewery (established in 1875), the first salmon cannery north of the Columbia River (established in 1877), and the Blackman Brothers Logging Railroad (established in 1887). The Seattle and Montana Railway arrived in 1891. The first Rosehill School was built in 1893; it would burn down and be rebuilt in 1928.

Due to its deepwater harbor and forested hillsides, logging became the principle industry. Mukilteo Lumber Company was established in 1903. This saw a large immigration of Japanese people to Mukilteo. The 1905 census for Mukilteo showed 300 whites and 150 Japanese. The Japanese people were primarily living in an area referred to as "Japanese Gulch." Charles Nelson purchased the mill in 1906 and renamed it Crown Lumber Company. It continued to provide employment until the Great Depression in 1930. The vacant mill burned down in 1938.

In 1906, Mukilteo Lighthouse began operations. P. N. (Peter) Christiansen was the first lighthouse keeper. A powder plant soon followed. Located in Powder Mill Gulch, the Puget Sound and Alaska

Powder Mill would rock the community when a spark ignited the powder, causing an explosion that would rattle windows and shatter glass as far away as Everett in 1930. A car ferry was established between Mukilteo and Clinton in 1919. The ferries were called the *Whidbey* and *Central II*.

During the Depression, Crown Lumber Company closed in 1930. Slowly, the Japanese immigrants moved away to look for work elsewhere. This was the era of Prohibition, and with its coves, gulches, and forested hillsides, Mukilteo was an ideal location for bootleggers and rumrunners. In 1931, rumrunner C. P. Richards established his bootlegging operation in Mukilteo. The brick house where he plied his trade is now a popular eatery known as Charles at Smuggler's Cove.

In 1941, World War II brought the U.S. Army Air Corps to Mukilteo. They were responsible for the construction of Paine Field, built before World War II. The U.S. Air Force built a fuel depot, or tank farm, on the waterfront in 1951. A steep railroad grade was built through Japanese Gulch in the 1960s. It ran from Paine Field to the bay. This rail line, stretching from the Boeing Company to the waterfront, continues to be utilized.

In 1947, Mukilteo was incorporated. At the time, its population was 775. Ferry service to Whidbey Island began in 1947. The Washington State Ferry system was established in 1951, but was replaced by the Puget Sound Navigation Company's Black Ball Line. Mukilteo State Park was also developed.

Today Mukilteo is a thriving community. It boasts a population of 20,110 and encompasses 6.2 square miles. Mukilteo struggles with issues involving development, annexation, and environmental concerns. It offers award-winning schools. Boeing, Travis Industries, Electro Impact, and Mukilteo School District are the primary sources of employment. It also maintains close ties to its old town roots.

One

NATIVE AMERICANS

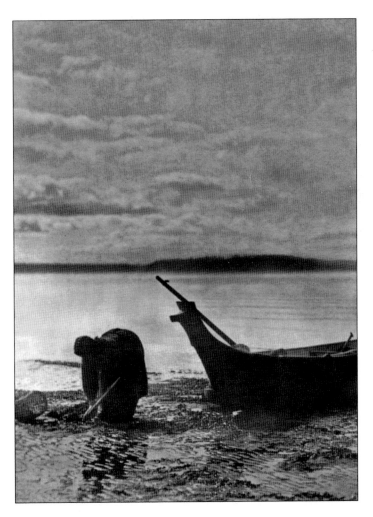

Long before the arrival of Captain Vancouver, Native Americans of the Northwest coast were living well. Puget Sound provided an abundant supply of food. Game roamed the forests, fish swam in the streams, and roots and berries grew amongst the open ground. The Snohomish people stretched from the foothills of the Cascades to Puget Sound. A hunting and gathering society, they traded goods with other tribes. They were not nomadic. Instead, they established permanent villages such as the one located in Everett called Hibulb. (Courtesy of Chicago's Northwestern University.)

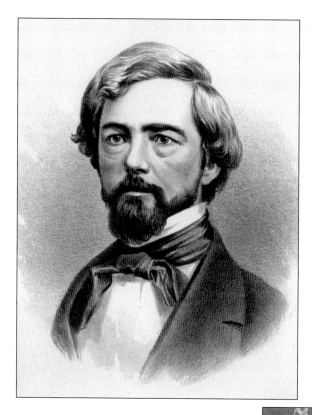

Isaac Ingalls Stevens was born in Andover, Massachusetts, on March 25, 1818. A physical defect rendered him small in stature; however, this did not impact his ambition or intellect. He graduated from the U.S. Military Academy at West Point first in his class. After fighting in the Mexican War, he was assigned to the Oregon Territory. Carrying the rank of major, he went to work for the U.S. Army Corps of Engineers. In 1853, Stevens became the first territorial governor of Washington at 35 years old. During this time, he identified 30 different Native American tribes in Puget Sound. Their population was estimated at 7,000 tribal members. Stevens is best known for his Point Elliott Treaty, which, amongst other things, ceded lands from the Native Americans. During the Civil War, Stevens led a volunteer army. He was killed at the Battle of Chantilly in 1862 at the age of 64. (Courtesy of the University of Washington.)

The peace treaty of January 22, 1855, was signed between Gov. Isaac I. Stevens and 82 Native American leaders. They chose Mukilteo for the meeting due to the fact their ancestors had met there for councils, potlatches, and social gatherings. The treaty articles of agreement at Mukilteo concluded that the Native American inhabitants would cede their lands to the U.S. government in exchange for relocation to reservations, retention of hunting and fishing rights, and an amount of cash. Instead of resolving problems, the treaty renewed conflicts. As a result, ratification was delayed until the spring of 1859. (Author's collection.)

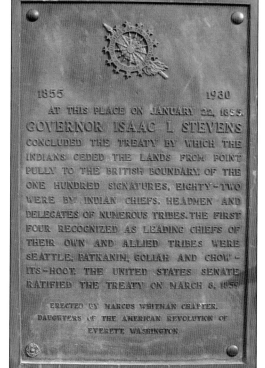

The Point Elliott Treaty included Native Americans of the Central Coast Salish tribes of Western Washington, from Puget Sound to the summit of the Cascade Mountains, and from the British boundary (49th parallel) to Seattle (Point Pully). Prominent signees included Chief Seattle of the Duwamish and Suquamish tribes, Chief Pat Kanim of the Snohomish and Snoqualmie tribes, Chief Goliath of the Skagit and Samish tribes, and Chief Cowitshoot of the Lummi and Nooksack tribes. There were no less than 22 distinct tribes whose headmen or delegates signed the treaty. About 2,500 Native Americans attended the signing. They came ashore at Mukilteo in canoes from different villages around Puget Sound. (Courtesy of the University of Washington.)

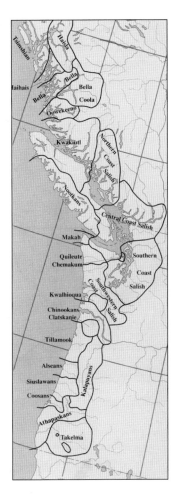

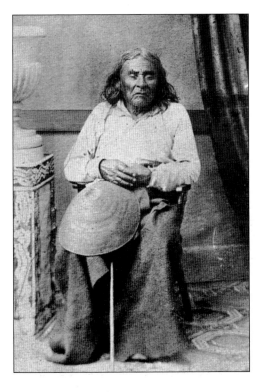

At the signing of the Point Elliott Treaty, the Record of Proceedings, which are housed by the Bureau of Indian Affairs in the National Archives, attributes these words to Chief Seattle in his address to Gov. Isaac Stevens: "I look upon you as my father, I and the rest regard you as such. All of the Indians have the same good feeling toward you and will send it on paper to the Great Father. All of the men, old men, women and children rejoice that he has sent you to take care of them. My mind is like yours, I don't want to say more." (Courtesy of the University of Washington.)

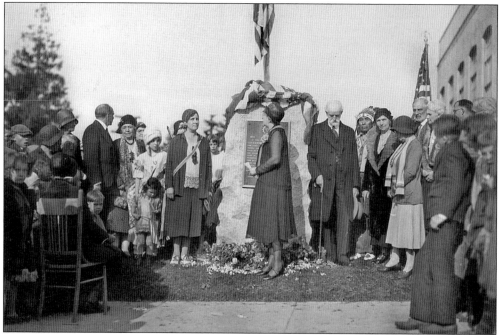

In 1930, the Daughters of the American Revolution paid tribute to the Point Elliott Treaty by erecting a granite monument at Mukilteo's Rosehill School. This picture was taken May 2, 1931. It shows University of Washington professor of history Edmond S. Meany, the bearded man holding his hat and cane. To the right of him is Chief William Shelton of the Tulalip tribes in a feathered headdress, and Ms. Gilman of the Everett-based Marcus Whitman Chapter of the DAR is standing to the right of Chief Shelton. Governor Hartley is standing to the left in a dark suit. (Courtesy of the University of Washington.)

Representatives of the Swinomish, Sammish, Suquamish, Lummi, Skagit, Upper Skagit, Snoqualomie, and Snohomish tribes attended the program unveiling the monument commemorating the treaty at Mukilteo. The ceremony included speeches by Kate Stevens Bates, daughter of Gov. Isaac I. Stevens; University of Washington professor of history Edmund S. Meany, who composed the words for the monument; and Chief William Shelton of the Tulalip tribes. (Courtesy of the Mukilteo Historical Society.)

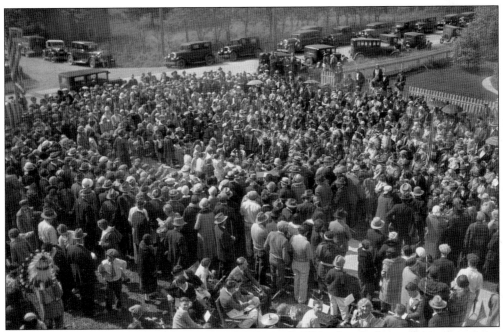

The unveiling ceremony gathered more than 3,000 people. Three hundred were Native American, and some were descendants of the original treaty signers. To this day, there have been numerous commemorations of the Point Elliott Treaty. Major ceremonies have been held in Mukilteo, and the leadership of the Tulalips and other tribes, as well as local and state elected officials, play an important part of the festivities. Treaty Days, an annual event on the Tulalip Reservation, takes place in late January. The event includes traditional spirit songs and dancing at the Tulalip longhouse. (Courtesy of the Mukilteo Historical Society.)

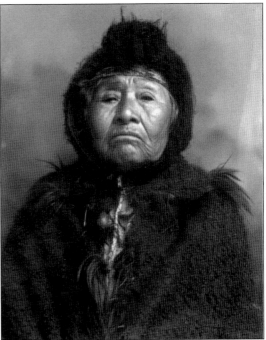

Pilchuck Julia lived in Snohomish from the early 19th century into the 20th century. Born in the 1840s, she spoke of having been present at the signing of the treaty in 1855 in Mukilteo. Regarded as queen of the Pilchuck tribe, Julia was known statewide as a weather prophet, predicting the big snow of 1916. That year, 4 feet of snow fell. Julia, the last full-blooded member of the Pilchuck tribe, died in 1923. She was believed to be 80. Julia is buried in the Snohomish Cemetery. (Courtesy of the Everett Public Library.)

13

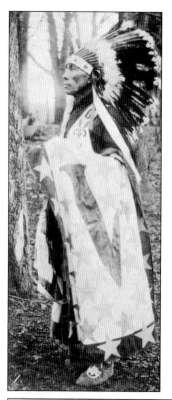

Chief William Shelton of the Tulalip tribes (1868–1938) was known as a great teacher, wood carver, storyteller, and cultural leader. At the time of his birth, Coast Salish cultural traditions had been nearly decimated by contact with the white settlers. Shelton spent his life gathering, sharing, and preserving the remaining tribal traditions. He earned the respect of Native Americans and non-natives alike. Working to unite these cultures, Shelton was a key figure in the preservation of Coast Salish traditions. (Courtesy of the Mukilteo Historical Society.)

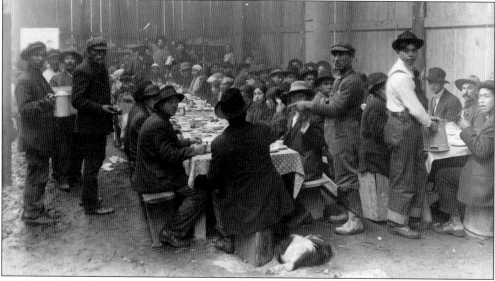

The Point Elliott Treaty remains a living document. Tribal fishing rights were restricted after 1890. This governmental restriction continued into the 1950s, and protests began in the 1960s. Tribal fishing rights were reconfirmed in 1974 when Judge George H. Boldt issued his decision that the "off-reservation fishing areas of the Tulalip tribes included those of the aboriginal Snohomish and Snoqualmie tribes holding that, as successors of these tribes, the Tulalip tribes hold their treaty fishing rights and are entitled to fish in their usual and accustomed fishing areas." (Courtesy of the Everett Public Library.)

Fr. Eugene Casimir Chirouse was born on May 8, 1821, in Bourge-de-Peage, France. Having heard about the Native Americans' interest in Christianity, Chirouse became a priest among the natives in the west. He was assigned to a permanent mission with the Snohomish on Tulalip Bay in 1857. During this time, he established a school and church, the Mission of St. Anne. A master of Salish dialects, Chirouse authored books on grammar and catechism, translated scriptures, and created an English–Salish/Salish–English dictionary. He also taught religion, farming, and wood carving. Father Chirouse worked to see that the government fulfilled its treaty commitments to provide funds to maintain the church and buildings, as well as books, clothing, and medical care. (Courtesy of the Snohomish County Museum of History.)

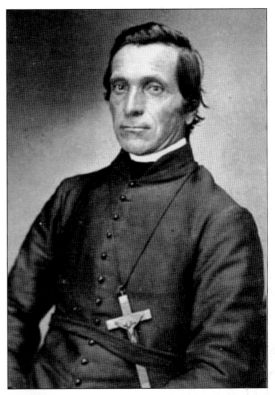

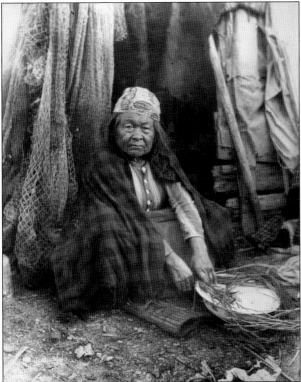

Many have asked why the Native Americans signed the Point Elliott Treaty. It's become obvious they didn't understand the nature of the document. For one thing, negotiations took place using a trade language called Chinook Jargon, which consisted of approximately 300 words. Also, having lost half their population to smallpox, other diseases, and attacks by settlers, the Native American people were desperate. They welcomed the protection and assistance offered by the American government. (Courtesy of the Everett Public Library.)

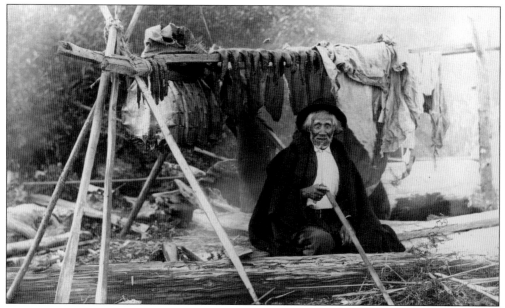

In 1934, Congress enacted the Indian Reorganization Act. The purpose was to encourage tribes to take a direct role in managing themselves. This meant tribes could strengthen and revitalize their tribal governments. Members of the Snohomish, Snoqualmie, and Skykomish tribes formed a single reservation government at Tulalip. As part of the alliance, they adopted one name for themselves—Tulalip. It is taken from the Salish word for "the bay on the reservation." As a result, the tribes formed the Tulalip tribes of Washington. To this day, all Tulalip tribal members are descendants of tribes that signed the Point Elliott Treaty. (Courtesy of the Everett Public Library.)

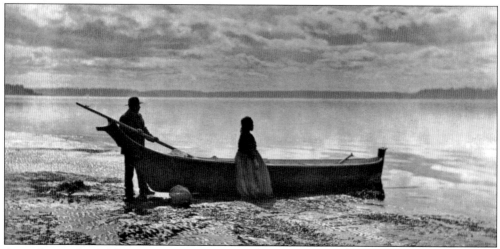

According to the Tulalips, "Today the Tulalip tribal population is about 4,000 and growing. Close to 2,500 live on the 22,000-acre Tulalip Indian Reservation, situated north of Everett, Washington. Upholding their right to tribal sovereignty. This can be witnessed in a strong tribal government; tribal opportunities for education, land, jobs, and housing; the promotion of tribal community through physical, spiritual and emotional happiness; the perpetuation of environmental and cultural sensitivity; improved infrastructure; and an improved tribal economic base for young tribal members." (Courtesy of Chicago's Northwestern University.)

Two

EXPLORERS

It was slightly prior to midnight on May 30, 1792, when British captain George Vancouver (1757–1798) anchored his flagship *Discovery* at Mukilteo. The next morning, he conducted measurements "on a low point of land near the ship." At a point near what is now Mukilteo's light station, the expedition's naturalist, Archibald Menzies, walked the beach collecting plant specimens. Because the Nootka rose, or rosa nutkana, was in full bloom, Vancouver chose to name the place Rose Point. (Courtesy of Steve Mayo.)

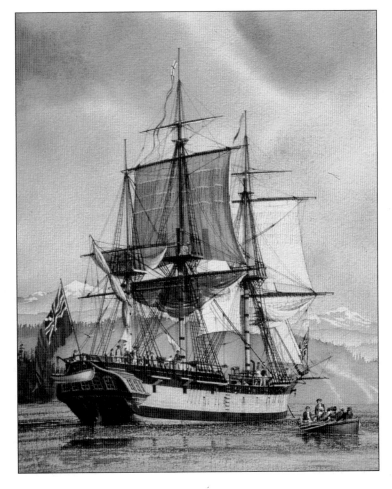

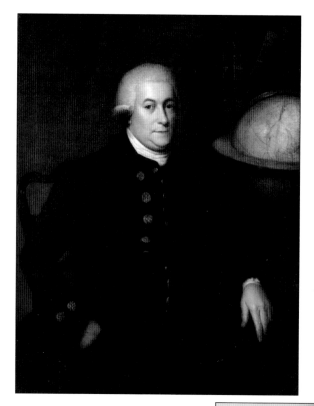

Vancouver was charged by the British to conduct a maritime exploration of North America's northwestern Pacific coast regions. This included the previously uncharted coasts of Oregon, Washington, British Columbia, and Alaska. Every inlet and outlet of the 5,000 miles of coastline was to be charted. Most of the work was done in small boats. Vancouver, the last 18th-century explorer to chart by sea the Pacific Northwest coast, named Puget Sound, Possession Sound, and Port Gardner. His charts were so accurate they were still being used into the 1920s as an aid to navigation. (Courtesy of the Everett Public Library.)

Rose Point remained the English name into the 19th century. In 1841, U.S. Naval Lt. Charles Wilkes anchored his three-masted sloop-of-war, *Vincennes*, off Mukilteo and changed the location name from Rose Point to Point Elliott on U.S. charts, in honor of midshipman Samuel Elliott. The Wilkes Expedition (1838–1842), which included seven vessels and 490 men, was organized to strengthen the United States's claim on the region. At the time, trade belonged predominately to Britain's Hudson's Bay Company. Because of his obsessive behavior and strict code of discipline, some historians believe Wilkes helped shape Herman Melville's depiction of Ahab in Moby Dick. (Courtesy of the Everett Public Library.)

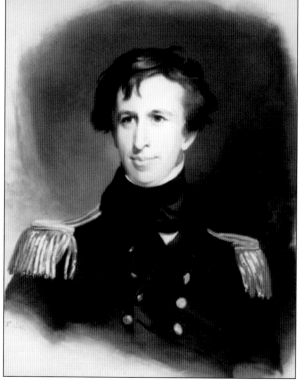

Three

FOUNDERS

Morris Frost (1804–1882) was born in Pougkeepsie, New York, in 1804. He traveled to the Northwest in the 1850s and took a job as collector of customs in Port Townsend. Through business dealings around Puget Sound, he became convinced that Point Elliott was the logical location for a trading post. Approaching J. D. Fowler, who operated a hotel and saloon at Ebey's Landing on Whidbey Island, the 54-year-old Frost proposed a partnership might prove beneficial. Together they established the first white settlement in Mukilteo. (Courtesy of the Everett Public Library.)

AFFIDAVIT REQUIRED OF HOMESTEAD CLAIMANTS, ACTS OF MAY 20, 1862, AND JUNE 21, 1866.

The Homestead Act of 1862 provided for the transfer of 160 acres of unoccupied land to homesteaders who paid a small fee after five years of residency. Plat records show Frost filed for 159 acres, and his fee was $11.99. He claimed the land that eventually became the town. After five years, Frost traveled to Olympia where he presented two sworn statements by people of "respectability" proving he had met the requirements of the act. Having proved his claim, Frost paid the required fee of $1.99. According to Frost's affidavit required of homestead claimants, he swears he settled on the land and has resided there since July 3, 1860. Consequently, the date Mukilteo first settled is known. (Courtesy of the Mukilteo Historical Society.)

Native New Yorker Jacob Fowler (1837–1892) operated the county's first post office in his saloon. He was just 24 when he served as the county's first auditor in 1861. When Mukilteo became the first county seat, Fowler served as treasurer. Fowler is credited with calling the place Mukilteo. This approximation of the Indian word "mew-kill-too" means "good camping ground" or "neck of a goose." He was married to Mary Warren, a Skagit Native American, who ran away from her parents when she didn't wish to marry a brave they had chosen. They remained in Mukilteo, raised a family, and ran various businesses. Fowler settled on his land in September 1860. His 157.51 acres cost $11.97. Adjoining Frost, Fowler's claim lies north. Through letters housed in the University of Washington's Special Collections, he describes early life in Mukilteo: "It is lonesome up here and very quiet. Trade is very dull, but I live in hopes of it being better one of these days." (Courtesy of the Everett Public Library.)

Four

TALL TIMBER

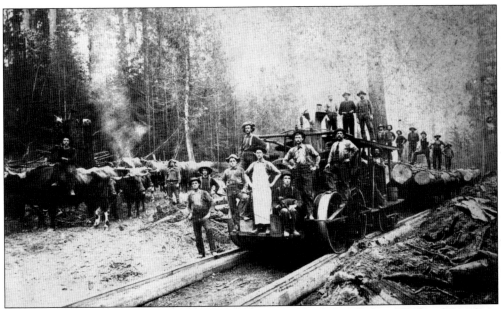

The Blackman Brothers Logging Railroad, built by the North Pacific Iron Works of Seattle in August 1881, was the first locomotive to operate in Snohomish County. This photograph, taken in 1883, shows the railroad's wooden rails at Mukilteo. (Courtesy of Christopher Summit.)

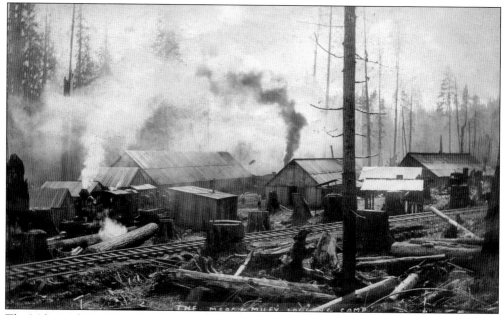

The Miley and Mead Logging Company began operation in 1905. Charles W. Miley (1863–1945) was a well-known Everett investor, logger, and realtor who had an office on Everett's Hewitt Avenue. Miley had various partners and coinvestors over the years. Dr. Chauncey A. Mead (1862–1933) was just one of them. Their investment in a logging enterprise lasted a very brief time. Within a year or two, they had both gone their separate ways. (Courtesy of the University of Washington.)

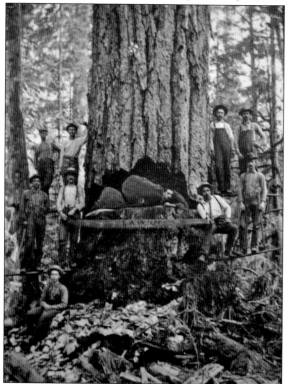

Douglas fir is a genus of trees that contains six species. Two species can be found in North America and four in eastern Asia. Because of its resemblance to other genera, botanists have mistakenly referred to it as a pine, hemlock, spruce, or true fir. In 1867, due to its distinctive cones (woody cones with pitchfork-shaped bracts that hang downwards), the tree was given its own genus—Pseudotsuga, or "false hemlock." Though not a "true" fir, only the Douglas fir is native to the Pacific Northwest. Donated by Harry Klemp, this 1915 photograph shows early Douglas fir logging in Mukilteo. (Courtesy of the Mukilteo Historical Society.)

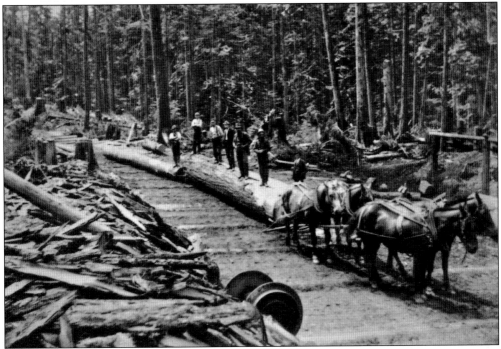

Early logging in the Northwest was done by hand using oxen to roll and skid logs to the water for transportation to mills. Horses eventually replaced oxen because they were quicker and easier to control. (Courtesy of the Port of Everett.)

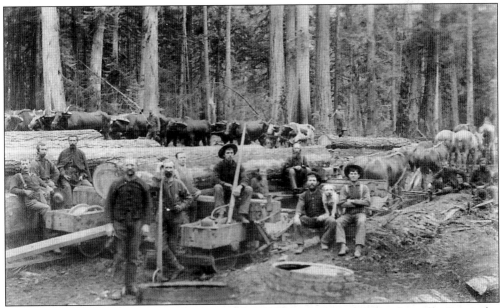

Due to its strength and size, Douglas fir was the chief species processed at the mills. It was also quite prevalent at the lower elevations. (Courtesy of the Port of Everett.)

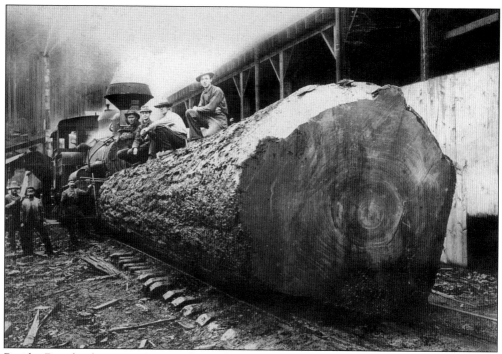

Besides Douglas fir, pine, spruce, cedar, and hemlock were cut, stored, and shipped from Crown Lumber Company. (Courtesy of the Port of Everett.)

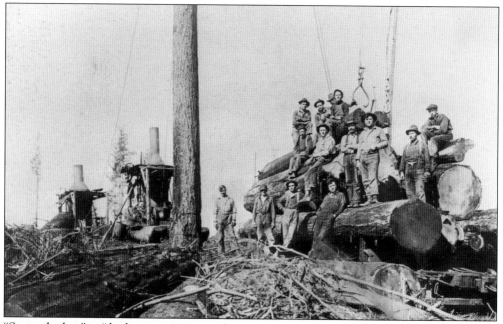

"Steam donkey," or "donkey engine," is a nickname for a steam-powered logging engine. Originally used in sailing ships, the donkey engine was often used to load and unload cargo and/or raise the larger sails. In terms of logging, the method of operation involved a horse hauling a cable to a log in the forest. Then, a cable would be attached, and, upon signal, would drag or skid a log towards the steam donkey. The log would then be transferred to a mill. (Courtesy of the Port of Everett.)

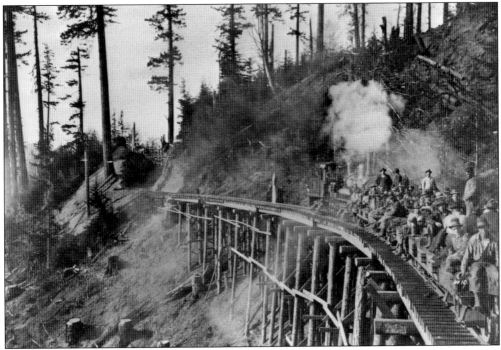

As logging moved away from the water, a railroad became the logical means of transportation to Possession Sound. (Courtesy of the Port of Everett.)

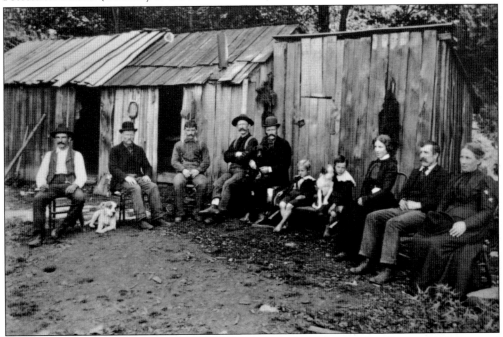

In the early 1900s, logging sites began to construct camps. Families lived in small shacks, and children were educated in one-room schools. Because they frequently moved, establishing lasting friendships with the town folk was rare amongst logging families. (Courtesy of the Snohomish County Museum of History.)

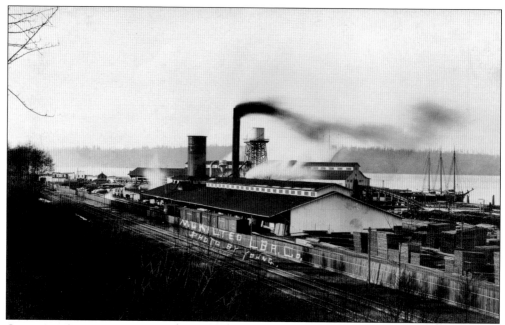

Crown Lumber Company, originally the Mukilteo Lumber Company, was built in 1903 and was one of the largest mills in Puget Sound. Mukilteo was an ideal location for a sawmill because the deepwater harbor allowed ships to dock easily, and they could hire Japanese workers. (Courtesy of the Mukilteo Historical Society.)

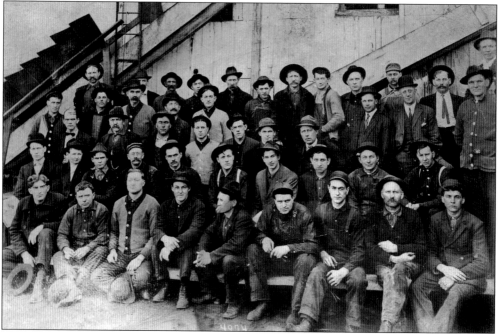

In 1905, the population of Mukilteo was estimated to include 150 Japanese and 200 whites. Crown Lumber Company employed most of the men. They worked various parts of the plant—sawmill, lumberyard, and wharf. Common labor rates were $2 to $2.50 per day for 10 hours of work. (Courtesy of the Mukilteo Historical Society.)

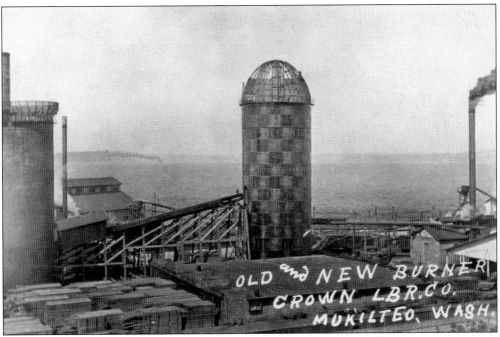

Crown Lumber Company was not just one of the largest mills on the West Coast in the early 1900s; it also boasted the largest burner, measuring 130 by 50 feet. (Courtesy of the Mukilteo Historical Society.)

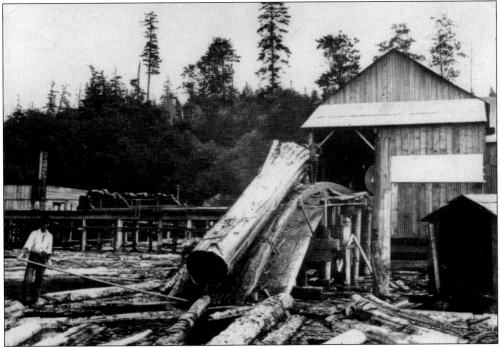

The mill had a capacity of 200,000 board feet per 10-hour day. Approximately 1.7 billion feet of forest products were produced during the life of the mill. (Courtesy of the Mukilteo Historical Society.)

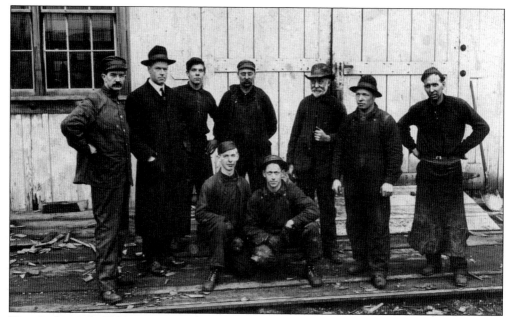

During the early 1900s, most Northwest mill towns met the increasing number of Japanese immigrants with hostility. They feared losing their jobs to the Japanese people who worked longer hours for less pay. For the Japanese community, the early 20th century was a time of prejudice and threats. However, the people of Mukilteo found a way to put their differences aside and work together. (Courtesy of the Mukilteo Historical Society.)

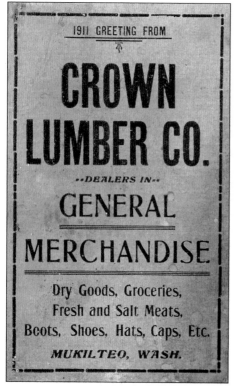

This 1911 ledger from the Crown Lumber Company was used to keep record of orders placed for merchandise. The writing inside this booklet reads, "6 lbs. salt pork, 1 can chip beef and 100 lbs. white sugar—Ernest Simons, Mukilteo, Wash." (Courtesy of Paul Reynolds.)

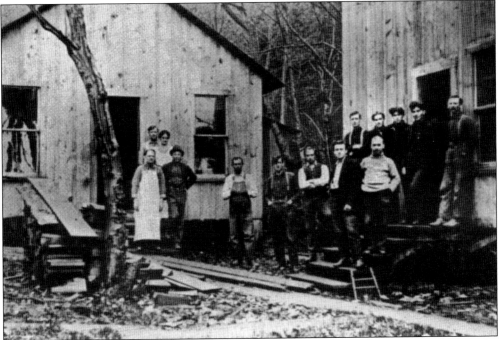

This photograph shows the Shingle Mill Cookhouse. Though it's called Edgewater Beach, the location where this photograph was taken is still known by the locals as "Shingle Mill Beach." (Courtesy of the Mukilteo Historical Society.)

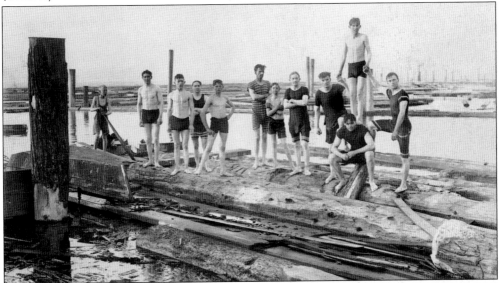

Beverly (Dudder) Ellis recalled, "In the late '20s, we'd often go down and play at Shingle Mill Beach. When the tide was out, we'd swim to where Crown Lumber Company had the log booms tied to pilings. We'd climb on the logs and either jump up and down, or jump from log to log. If a kid fell in the water, they had to swim under the logs till they saw an opening of daylight. It was kind of dangerous. Anyway, we never told our mother about it!" This photograph shows workers from Crown Lumber Company taking a swim after a day of hard work. (Courtesy of the Mukilteo Historical Society.)

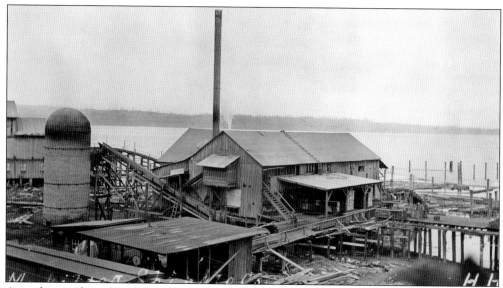

According to *Ships of the Redwood Coast* by Jack McNairn and Jerry MacMullen, "The sawmill shut down permanently in 1930, in the early part of the depression. At the time, it was noted, 'with excessive maintenance costs, burdensome insurance, and idle fleet of vessels and wharfage fees, the company was forced into receivership.' " (Courtesy of the Mukilteo Historical Society.)

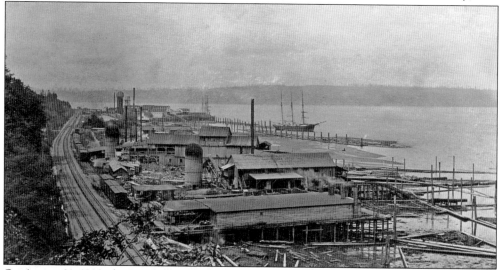

On August 31, 1938, the *Seattle Post-Intelligencer* reported, "A tall smokestack, two small buildings at the extreme north end of the property and a broad expanse of charred and smoking timbers were all that remained tonight to mark what once was the large Crown Lumber Company mill at Mukilteo. The plant was destroyed today by a fire that started about 9:00 a.m. and swept across the plant, doing damage estimated at between $75,000 and $100,000. Hose lines strung across the Great Northern track by firemen battling the blaze were severed by an engine that came upon the scene in the fog too late to stop. The hose line was later strung under the track. The plant had been unused for six or seven years. Originally built in 1903, it was last operated by the Charles Nelson interests of San Francisco. Last spring dismantling operations were begun, but most of the machinery was reported in the mill when the fire broke out. Cause of the blaze was in dispute." (Courtesy of the Mukilteo Historical Society.)

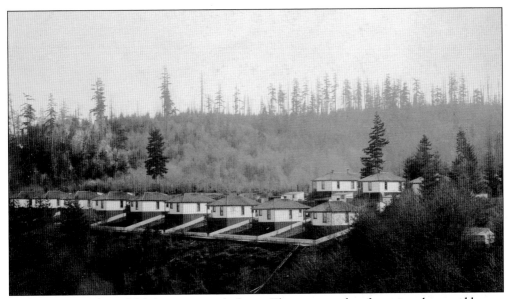

"When we came here, Mukilteo was mostly forest. There were only a few privately owned homes between Loveland and Prospect. The mill company had a row of 12 cottages on the edge of Second Street, above the mill. These cottages were rented to families that worked in the mill. In later years, as people built their own homes, the cottages were rented to Japanese families," said Clara Bartle Kane. The above quote is from Opal McConnell's book *Mukilteo: Pictures and Memories*, in the section "Memories of Mrs. Bartle Kane." (Courtesy of the Mukilteo Historical Society.)

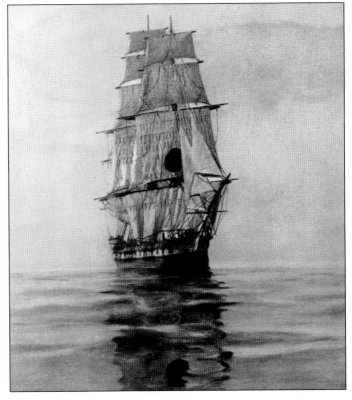

Midori Tanabe recalled, "It was in the early 1900s when a handful of Japanese immigrants made their long voyage from the islands of Japan to the shores of Mukilteo, a little sawmill town in America. Few spoke English. Most spoke none at all. But it was a good place with kind people, as they all worked hard, side by side, with the people of Mukilteo." (Courtesy of the Washington State Historical Society.)

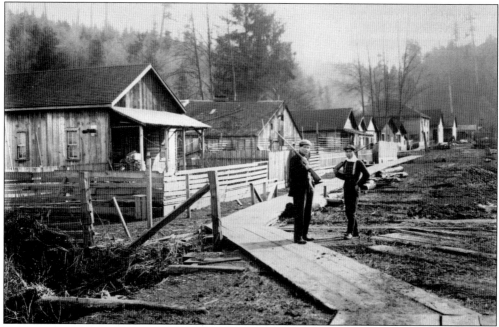

Facing toward the west, this picture of the village in Japanese Gulch shows the homes of Japanese immigrants who worked at Crown Lumber Company in 1926. These two boys may have been hunting, as game was plentiful in Japanese Gulch before the trees were cut down. (Courtesy of the Mukilteo Historical Society.)

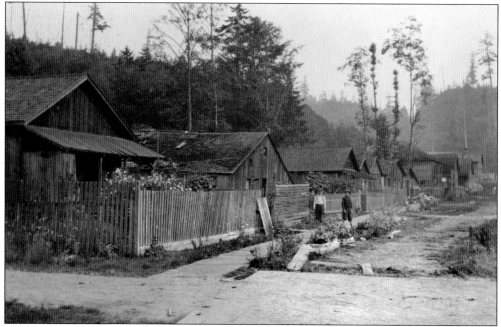

Many Japanese immigrants quickly recognized the importance of learning English and trying to understand American customs, and a number of the Mukilteo residents were eager to assist. They taught the Japanese people to read and write, while the female residents helped the women learn to cook, bake, and sew. (Courtesy of the Everett Public Library.)

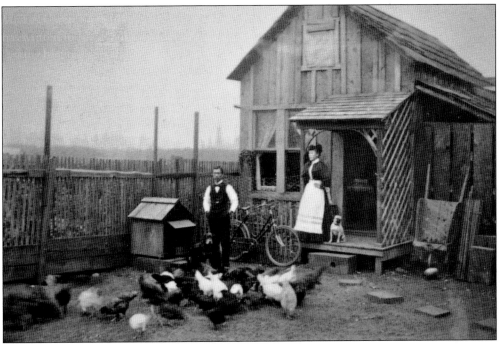

When Crown Lumber Company closed in 1930, the Japanese immigrants who had worked at the mill gradually moved away, searching employment elsewhere. Many locals went to work at Everett's Weyerhauser Mill. The Great Depression not only cost Mukilteo jobs and incomes, but a vital part of its population as well. (Courtesy of the Mukilteo Historical Society.)

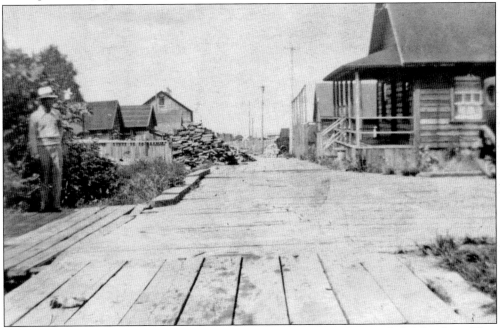

According to Clara Kane, "The Japanese made contributions to the Rosehill School . . . They paid for one of the utilities, bought the curtain for the stage, and also gave two busts, one of Washington and one of Lincoln." (Courtesy of the Mukilteo Historical Society.)

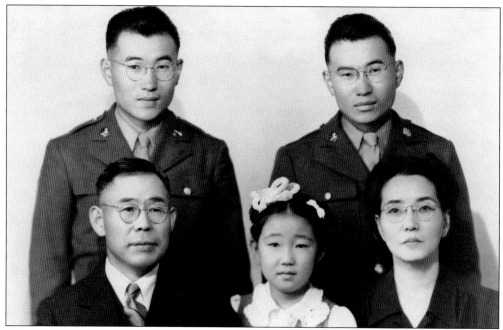

Mas Odoi remembered, "In 1927, when my twin brother Hiroshi and I were six years old and living in Mukilteo's Japanese Gulch, an older playmate teased us by asking: 'If there is a war between the United States and Japan, whom will you fight for?' 'For America, of course,' Hiro and I said simultaneously. 'Would you shoot down your own cousin if you ran across him?' our friend persisted. 'I guess I'll have to,' I answered. Somewhat disconcerted, we went to mama and asked, 'If there is war between America and Japan, whom should we fight for?' 'What are you? American or Japanese?' she asked. 'Americans, of course,' we said. She just smiled." Above is Mas Odoi (top left) and twin brother Hiroshi with their parents and sister, Miriam, prior to the boys leaving for France with the 442nd Regimental Combat Unit. (Courtesy of the Mukilteo Historical Society.)

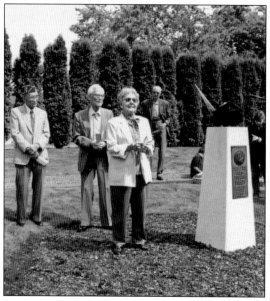

On June 9, 2000, descendants of the original Japanese immigrants gathered with the present citizens of Mukilteo to dedicate a monument honoring the town's early efforts to establish racial harmony. A bronze origami crane, symbolizing peace and harmony, was erected at 1126 Fifth Street in Centennial Park. This photograph shows Beverly (Dudder) Ellis speaking at the ceremony. In the background (far left), one can see Mas Odoi, who grew up in Japanese Gulch. (Courtesy of the Mukilteo Historical Society.)

Five

SAILS

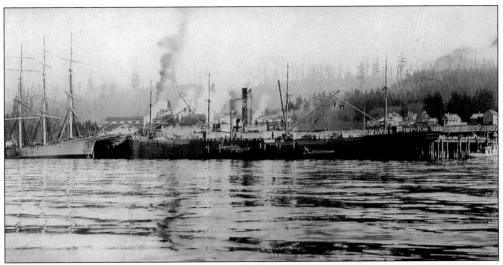

The Crown Lumber Company was one of the busiest and largest mills on Puget Sound. With its glacier-carved deepwater harbor, it wasn't uncommon to see numerous tall-masted vessels loading lumber at the 10-acre mill. (Courtesy of the Mukilteo Historical Society.)

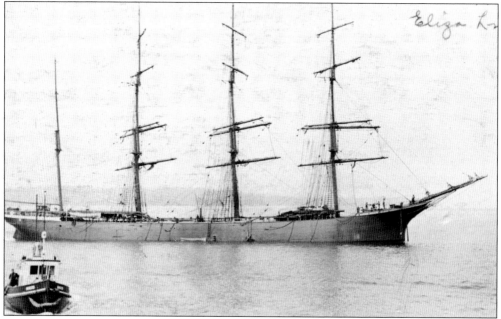

Taken by Charles McNab in 1913, this photograph shows the four-masted ship *Elisha Lihn* in Possession Sound. (Courtesy of the Mukilteo Historical Society.)

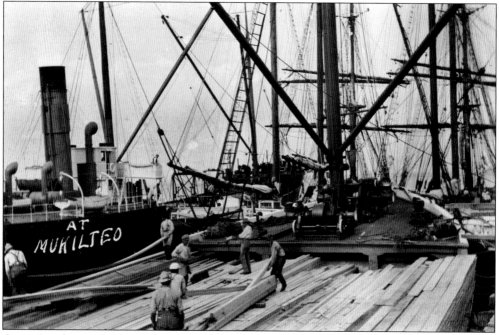

Crown Lumber Company employed about 200 men. An additional 30 to 60 longshoremen worked at the mill. (Courtesy of the Mukilteo Historical Society.)

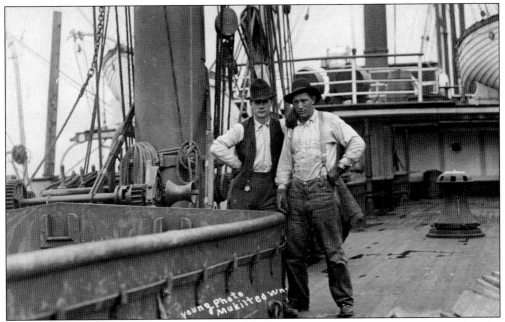

James G. Kaiser remembers, "A bulletin board was maintained in the pool hall for posting the date and arrival time of ships . . . Longshoremen were hired at the pool hall for each shipment of lumber. A gang of longshoremen consisted of one or two winch operators, one hatch tender, eight men in the ship's hold and two or four men on the dock. A gang was needed for each operating hold . . . The longshoremen usually received their pay in cash from the ship's officer aboard the ship after each job was completed. If that was not done, the stevedore boss paid off the crew at a designated time in the pool hall." (Courtesy of the Mukilteo Historical Society.)

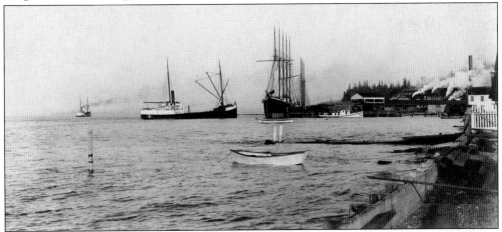

In the 1920s, the people of Mukilteo drained the lagoon and built dikes to develop a baseball field. The dike was built to provide land for a ballpark, not to keep the town from flooding. According to Marie (Josh) Kaiser, "The first dike extended from Losvar's Boat House to the railroad tracks. However, a strong southwest gale sent waves and logs battering the gravel and pilings until that dike was demolished." Eventually, a strong dike with large sluice box was constructed. However, efforts to hold back the sea continued to fail. By the 1940s, the park was once again a lagoon. It wasn't until fill dirt was used to create a state park in the 1950s that this land was reclaimed. (Courtesy of the Mukilteo Historical Society.)

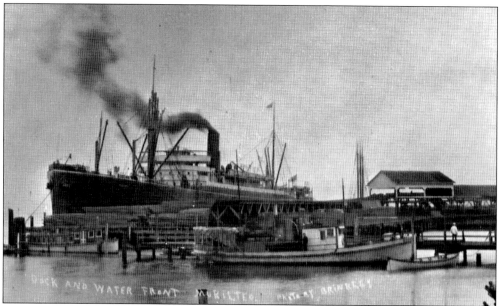

Before there were trains or roads, mail was carried by boat, such as the *Noreen* (pictured here). In the early days, the postmaster delivered mail to the boat. After the arrival of the Great Northern Railroad in Mukilteo, trains carried the mail. When a road was constructed between Mukilteo and Everett, mail was delivered by truck. (Courtesy of Paul Reynolds.)

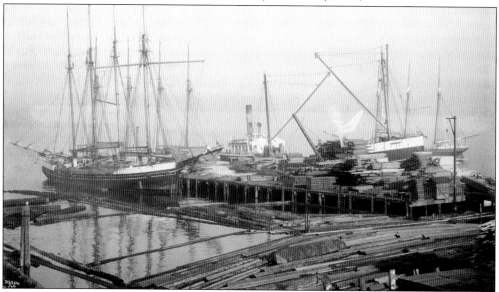

A number of sailing vessels, three-masted, four-masted, and five-masted ships frequented Crown Lumber Company. They included the *Vigilant*, *Commodore*, *Mashula*, *Crescent*, *Thistle*, *Melrose*, *Forester*, and *Alice Cooke*. These vessels carried around 500,000 to 1,600,000 feet of lumber per load. Steamships included the *Blue Funnel*, *Dollar*, *Matson*, and *Lewis Luckenbach*, which traveled to destinations such as California, Hawaii, and worldwide markets. The larger freighters (steel-hulled) carried in excess of 5,000,000 feet per load. In 1928, the *Lewis Luckenbach* carried the largest load up to that time—8,000,000 board feet. (Courtesy of the Snohomish County Museum of History.)

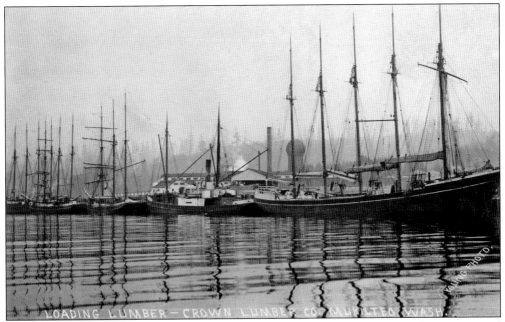

Crown Lumber Company also operated a small fleet of wooden steam schooners that transported lumber on the West Coast. These boats included the *Mukilteo, Port Angeles, Wilmington, Nome City,* and *Charles Nelson.* (Courtesy of the Mukilteo Historical Society.)

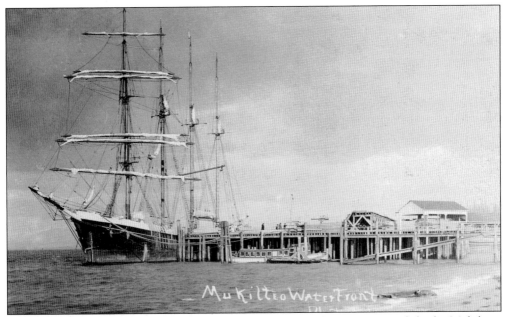

An 18th-century schooner loads lumber at the Crown Lumber Company while the Mukilteo-Everett passenger boat *Noreen* waits to take commuters to Everett. (Courtesy of the Mukilteo Historical Society.)

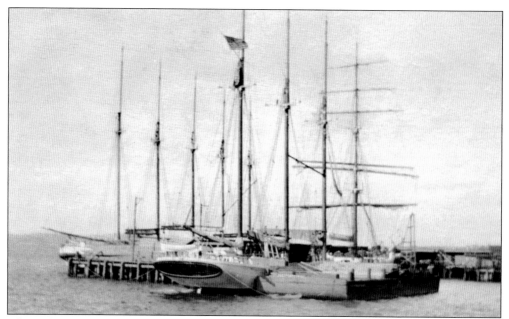

Alexander McDougall, a Scottish-born sea captain, designed a new freighter hull in 1872. The hull had a rounded deck (to shed water) and a flat bottom. This minimized resistance from water and wind. Because of its appearance when loaded, the ship was dubbed a whaleback. In 1894, a shipbuilding company was established in Everett, Washington. The whaleback steamship SS *City of Everett* was constructed. It was intended to be the first in a line of whaleback ships; however, changing economics conditions resulted in it being the only ship produced at the shipyard. The *City of Everett* sailed from 1894 to 1923. It was the first American steamship to circumnavigate the globe and the first to navigate the Suez Canal. (Courtesy of the Mukilteo Historical Society.)

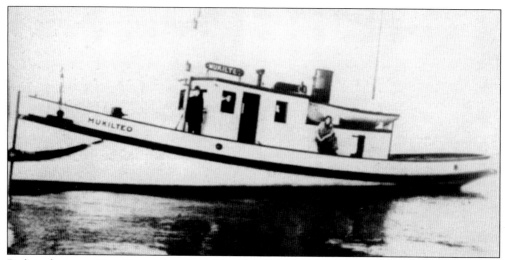

Built in the Losvar Boat House, the tug *Mukilteo*, used by the Crown Lumber Company, was captained by Joe Rearson. The engineer was Charles Camp. The tug was used to gather logs, move rafts of logs, or for periodic towing on Puget Sound. (Courtesy of the Mukilteo Historical Society.)

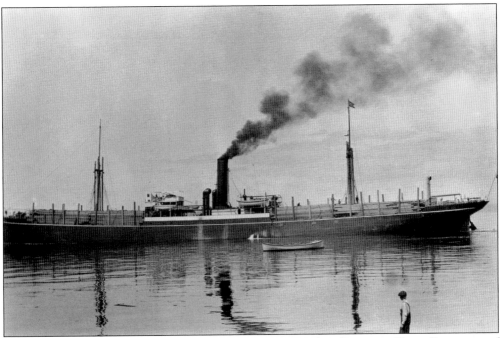

Sailing ships carried full loads when they left Crown Lumber Company. Typically, a gang of 14 longshoremen loaded them. This consisted of four men on the dock, a winch operator, a hatch tender, and eight men in the ship's hold. A steam donkey engine helped hoist the lumber aboard the ship. Ships usually stayed in port for two to four weeks. (Courtesy of the Mukilteo Historical Society.)

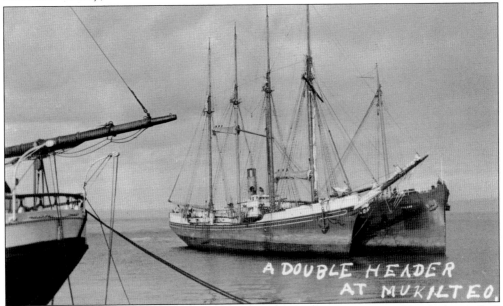

When two ships were at the wharf, it wasn't uncommon to place a phone call to the hiring hall in Everett for more longshoremen. Depending upon what was needed, either individuals or full gangs would be brought on. Everett often hired longshoremen from Mukilteo when the reverse situation existed. (Courtesy of the Mukilteo Historical Society.)

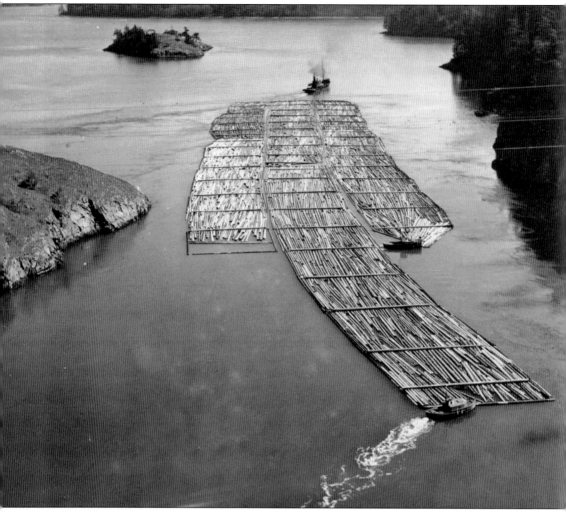

In the early days, it wasn't uncommon to sell timber by the homestead, acre, or claim. However, not everyone realized the profit dense stands of old-growth timber provided. Rather than sell their timber, some settlers cleared their land for grazing or agriculture by setting fire to the trees. Sadly, there was a market both home and abroad for such timber. (Courtesy of the Snohomish Historical Society.)

Six

RAILS

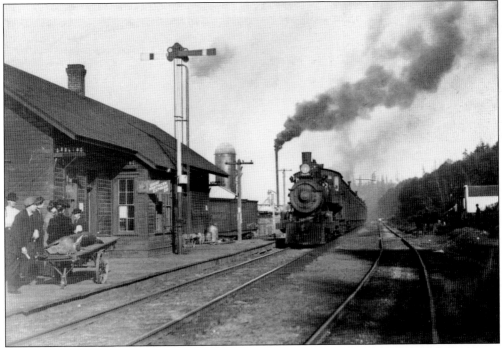

The Great Northern Railway was completed in 1893. When the last spike was driven, Puget Sound was linked with Minneapolis, St. Paul, and other destinations east. The railway, which was built over the Cascade Mountains via Stevens Pass, provided a transportation connection that sparked an economic boom in Snohomish County. (Courtesy of the Mukilteo Historical Society.)

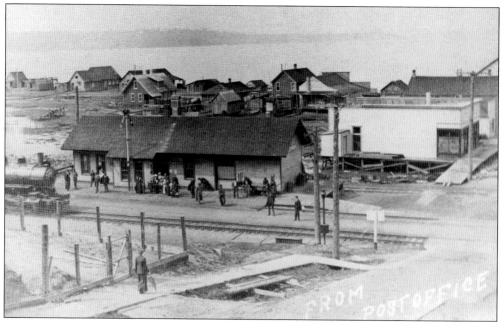

The railway and train station became an important part of life in Mukilteo. Everyone looked forward to the mail, which arrived by train. When the train was not scheduled to stop in Mukilteo, the mail sack was hung on a hook near the depot as the train rumbled through town. It would then be retrieved and brought to the post office for pick up. (Courtesy of the Mukilteo Historical Society.)

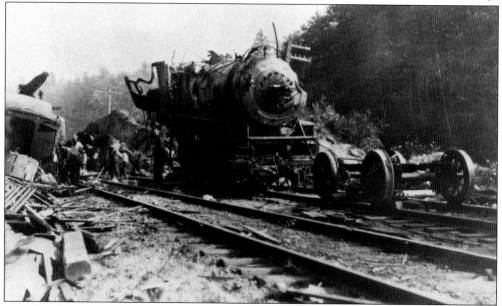

On Thursday, February 18, 1909, the *Mukilteo Enterprise* reported, "A few minutes after six o'clock Wednesday morning, February 10th, the people of Mukilteo were startled by an explosion, which shook the buildings and in a short time the word came that the boiler of the engine pulling the southbound Owl train had exploded about half a mile south of town. The engine was completely demolished and the engineer and fireman were killed." (Courtesy of the Mukilteo Historical Society.)

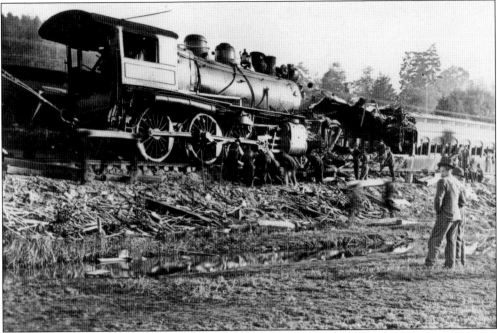

The whole town came out to see the great Mukilteo train wreck on September 22, 1913. Unfortunately, it wouldn't be the last train wreck in Mukilteo. (Courtesy of the Mukilteo Historical Society.)

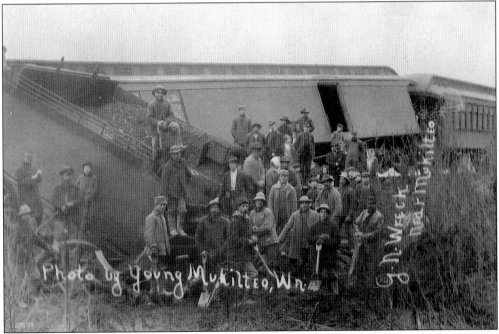

After a second line of the Great Northern Railroad was built, the soft fill dirt beneath the tracks was unable to support the train's weight. Consequently, the track collapsed and the locomotive was pitched on its side. (Courtesy of the Mukilteo Historical Society.)

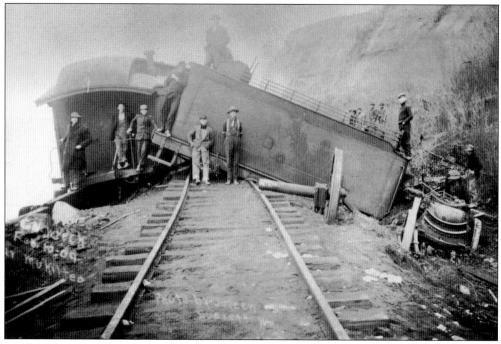

In all, Mukilteo experienced several train wrecks. One occurred near the ball field, and others south of town. (Courtesy of Mukilteo Historical Society.)

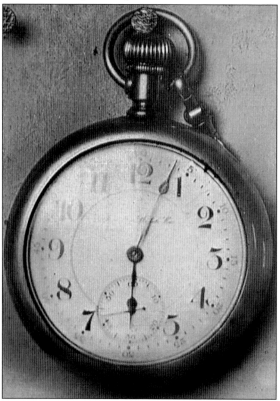

This watch, which belonged to a fireman, shows the correct time of the Great Northern Railroad wreck. The watch was such a unique find that the picture was made into a postcard by Robert Young. (Courtesy of Renee Ripley.)

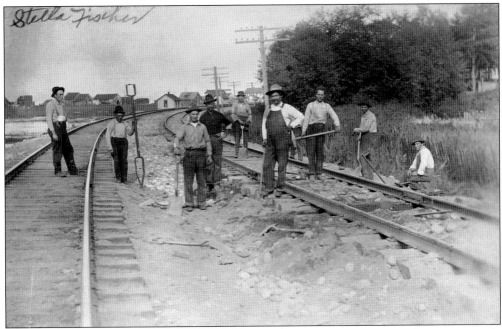

The locals called them "gandy dancers," a slang term used for early railroad workers. They maintained railroad tracks in the years before machines. The origin of the term is uncertain. It is generally thought to be a combination of "gandy" from the Chicago-based Gandy Manufacturing Company, maker of railroad tools, and the rhythmic movements of workers using a 5-foot rod, or gandy, as lever to keep the tracks in alignment. (Courtesy of the Mukilteo Historical Society.)

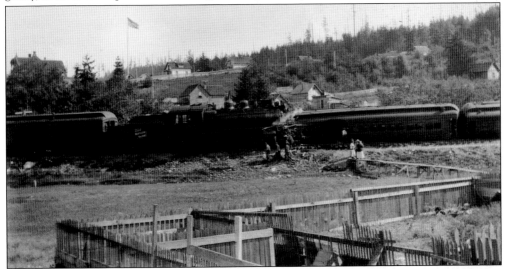

In his book *Crown Lumber Company*, James G. Kaiser described the railroad crossings situated in Mukilteo to protect people from the train, even though one employee of Crown Lumber Company was killed by a Great Northern train as he was walking home by way of the railroad tracks. "There were three crossings of the railroad tracks in town, one at Park Avenue, one at the main sawmill entrance opposite the sawmill office and one at Jap Gulch. Each crossing was designated by a large X-cross warning sign, painted white with black letters denoting "Railroad Crossing." (Courtesy of the Mukilteo Historical Society.)

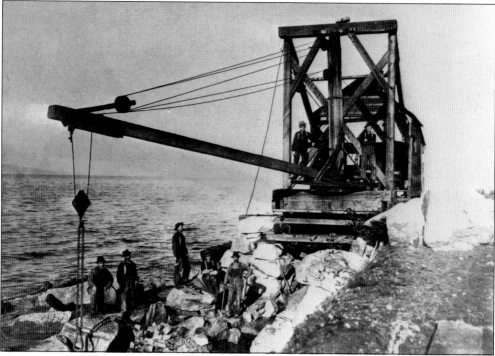

The rock seawall was built to protect the railroad from the pounding waves of Possession Sound. Helmer Moe, one of Mukilteo's pioneers, can be seen in this photograph standing on the crane that was used to lift the granite boulders. This seawall continues to protect the railroad tracks from Seattle to Bellingham. (Courtesy of the Mukilteo Historical Society.)

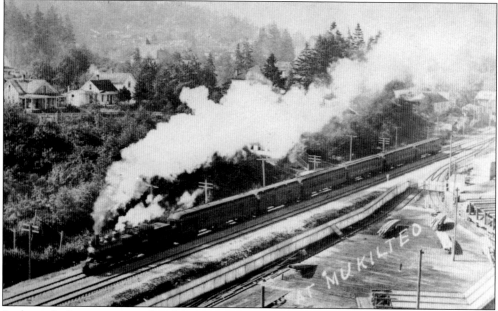

In the early days, one-way railroad fares to Everett were 10¢ for children and 15¢ for adults. Boat fares were 10¢ per person. Once bus transportation was available, it cost 15¢ for children and 25¢ for adults. (Courtesy of the Mukilteo Historical Society.)

Seven

OLD TOWN

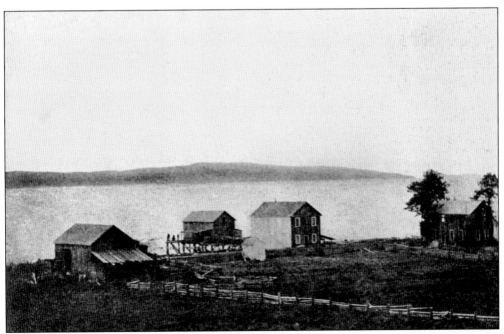

Provided by Frances Record, the granddaughter of J. D. Fowler, this is the first known photograph of the Frost and Fowler settlement in Mukilteo. (Courtesy of the Mukilteo Historical Society.)

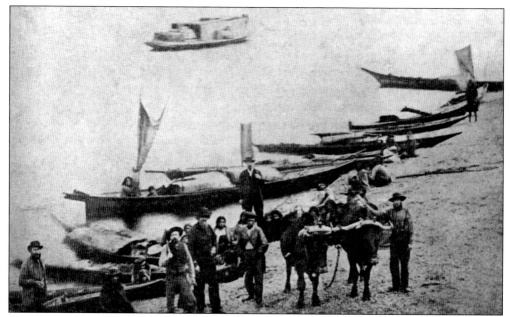

This image shows J. D. Fowler and his team of oxen on the beach at Mukilteo. Also pictured are a number of Native Americans with their canoes. The reason Frost and Fowler chose Mukilteo for a settlement was to trade goods with the Native Americans. This photograph was found in one of Fowler's diaries. He kept a daily record of early historical events in Mukilteo. His diaries were handed down to his granddaughter, Frances Record. (Courtesy of the Everett Public Library.)

Int. No. 2 Office No. 11.

United States. Patent Hd. Cert. No. 103.
 to Application No. 267.
Jacob D. Fowler. Dated May 2, 1870.
 Filed Aug. 16, 1872.
 Vol. 1 Deeds, page 19.
 Recites that there has been deposited in the general land
office of the United States certificate of the register of Land
office at Olympia Washington Territory whereby it appears that
pursuant to act of congress approved May 20, 1862, to secure
homesteads to actual settlers the claim of Jacob D. Fowler has been
established and consumated in conformity with law for the E½ of NE¼
of Sec. 4, the W½ of NW¼ of Sec. 3; Twp. 28 N. R. 4 E. and Lot 1,
of Sec. 34 Twp. 29 N. R. 4 E. in the Olympia Washington Territory
Land District; containing 157 acres according to official plat in
General Land Office.
 Grants to Jacob D. Fowler above described lands.
 Signed, U. S. Grant, President,
 By Charles White, Secretary.
 Rec. Vol. 1 page 119.
 J. M. Granger.
 Recorder of General Land Office.
 (S e a l).

Located on the corner of Fourth Street and Loveland Avenue, the initial recording of this piece of property was handled by J. D. Fowler. In 1907, Crown Lumber Company built the timekeepers shack on the property. (Courtesy of Marty and Wendy Eidbo.)

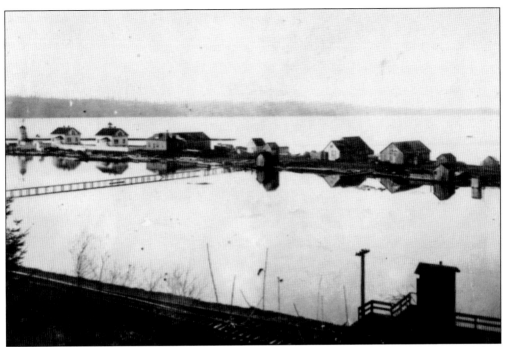

This 1900s photograph shows the lighthouse and early buildings along the waterfront in Mukilteo and illustrates the extent of the lagoon that extended almost to Park Avenue at high tide. Prior to a dike being built, the baseball field would often flood. The lighthouse was built on a long spit of land and explains one of the meanings for Mukilteo as "long neck of a goose." (Courtesy of the Mukilteo Historical Society.)

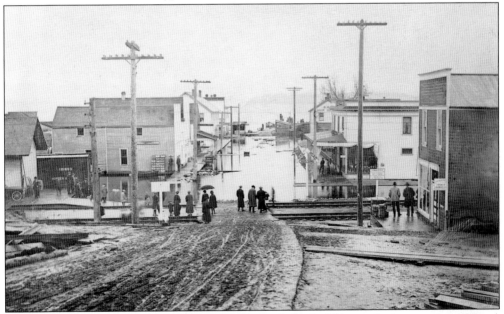

This photograph is a reminder of what very high tide looked like at the intersection of Front Street and Park Avenue, all the way up Park Avenue to the railroad tracks. (Courtesy of the Mukilteo Historical Society.)

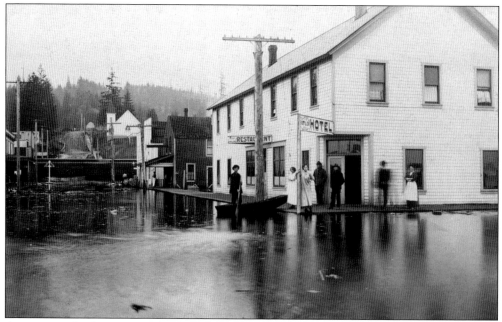

A man rows his boat across the road during high tide at the corner of Front Street and Park Avenue. "If you got a high tide and strong north wind during the winter, the saltwater would come right through McConnell's Boathouse and flood the whole lower part of town," recalled Beverly (Dudder) Ellis. (Courtesy of the Mukilteo Historical Society.)

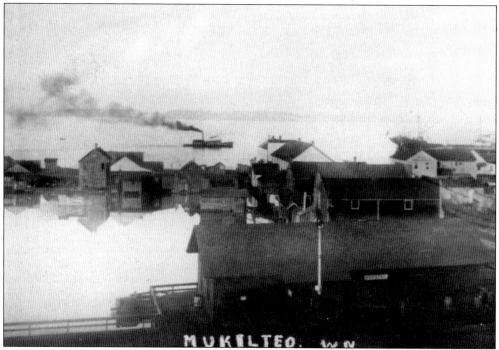

In the early 1900s, the lagoon at Mukilteo extended all the way to the backs of the buildings on Park Avenue. The buildings were erected on pilings. In the background, one can see the tug *Mukilteo* making its way north on Possession Sound. (Courtesy of the Mukilteo Historical Society.)

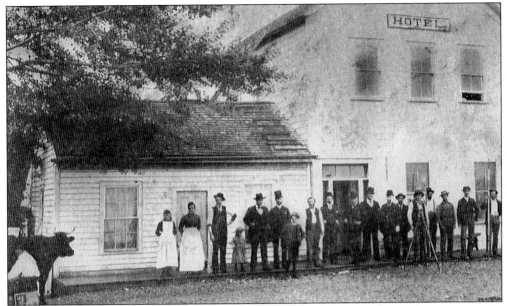

This picture shows J. D. Fowler's home, hotel, and exchange, the first settlement in Mukilteo. These were the only buildings along the waterfront. The rest of the area consisted of large trees that were eventually cleared for gardens, orchards, and other settlers' homes. In 1861, when Snohomish County was formed, a post office was founded in Mukilteo. It was located at the Fowler Store on Front Street. It was the first post office established in Snohomish County. (Courtesy of the Mukilteo Historical Society.)

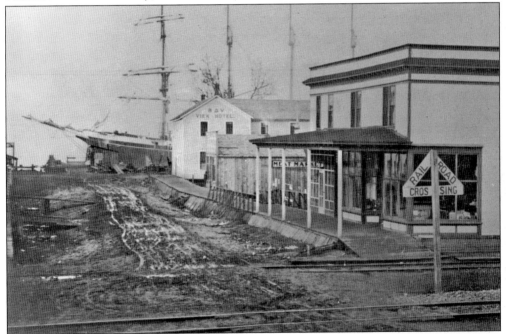

Looking down Park Avenue, this photograph, taken by Charlie Hurd in 1906, shows the tracks of the Great Northern Railroad, the Crown Lumber Company Store, Bayview Hotel, and a four-masted schooner in the background. (Courtesy of the Mukilteo Historical Society.)

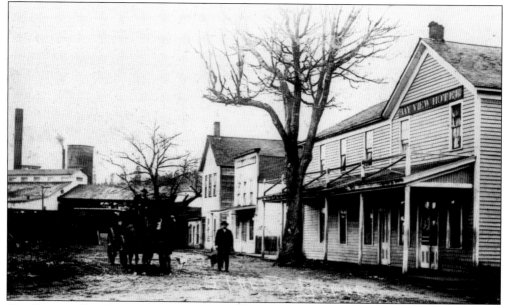

The Bayview Hotel was one of the first hotels in Mukilteo. In 1888, Louise Thomas leased and remodeled the hotel. It was to be operated as a summer resort. A dance pavilion, swings, croquet grounds, sailboats, and fishing were the main attractions. The rate was $2 per day, but there were special rates by week or month. Under the management of Thomas, the resort prospered. Located on Park Avenue and Front Street, the hotel became one of the town's favorite attractions. (Courtesy of the Mukilteo Historical Society.)

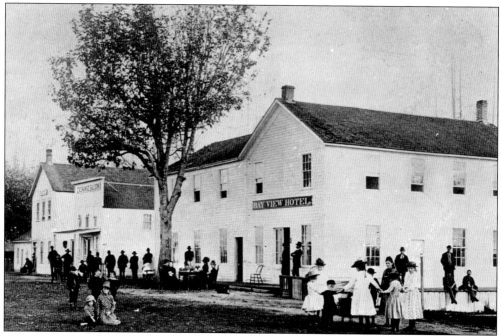

During World War II, the Bayview Hotel was converted to a barracks and housed enlisted men. When the war ended, the building was used for temporary housing and for an occasional boxing bout. (Courtesy of the Everett Public Library.)

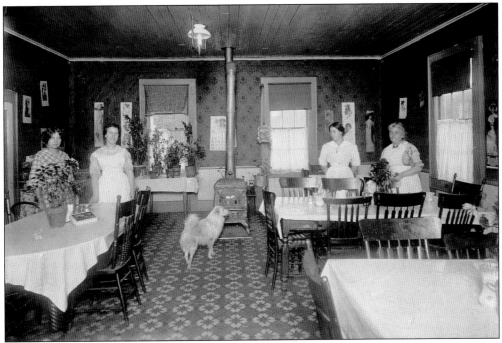

This picture shows the dining room of the Bayview Hotel. With loggers, sailors, and settlers frequenting Mukilteo, it became a popular gathering place. Pictured above are, from left to right, owner Elsie Foster, Kate (Foster) LaBeau, Frances Sinclair Record, and Mary (Lanbie) Foster. (Courtesy of Renee Ripley.)

The Bayview Hotel, which boasted of being the only "First-Class Summer Resort on Puget Sound," was originally owned by Walter Keyes. For $2.00 per day, one could enjoy such amenities as a trapeze, gymnasium exercises, swings, billiards, and warm or cold salt baths. Fishing and hunting opportunities were also available. The Bayview Hotel had the largest dancing pavilion on the north Pacific coast. This advertisement was from the 1887 R. L. Polk and Companies Directory. (Courtesy of the Everett Public Library.)

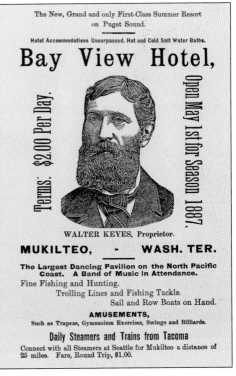

The New, Grand and only First-Class Summer Resort on Puget Sound.

Hotel Accommodations Unsurpassed. Hot and Cold Salt Water Baths.

Bay View Hotel,

Terms: $2.00 Per Day.

Open May 1st for Season 1887.

WALTER KEYES, Proprietor.

MUKILTEO, - WASH. TER.

The Largest Dancing Pavilion on the North Pacific Coast. A Band of Music in Attendance.
Fine Fishing and Hunting.
Trolling Lines and Fishing Tackle.
Sail and Row Boats on Hand.

AMUSEMENTS,
Such as Trapeze, Gymnasium Exercises, Swings and Billiards.

Daily Steamers and Trains from Tacoma
Connect with all Steamers at Seattle for Mukilteo a distance of 25 miles. Fare, Round Trip, $1.00.

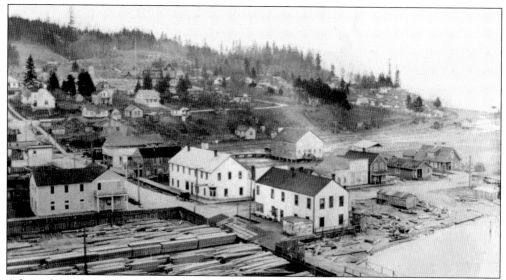

Advice from the Kennedy Investment Company Real Estate brochure read, "The quicker you make up your mind to put part of your savings in a few lots in an established manufacturing town that is, in reality, a suburb of Everett, 'the City of Smokestacks,' the sooner you will realize that you have an investment that will make you money. We appeal to the careful conservative investor who wants to know just what he is doing. All property between Everett and Seattle on the mainland, especially that with a Puget Sound view, is becoming more valuable every year. It will not be many years before it will be a continuous city from Tacoma to Everett. Will you buy now at from $25 to $50 a lot, or wait until later and pay the average city prices? $5.00 down and $2.50 a month on each lot will give you one more of the best lots left." (Courtesy of the Mukilteo Historical Society.)

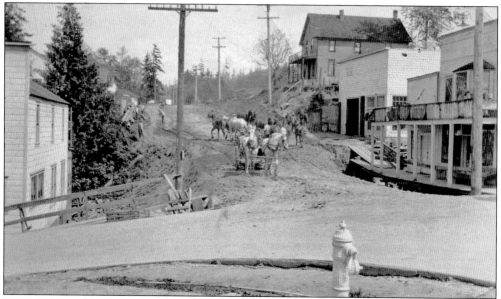

This photograph shows early transportation in Mukilteo. Located on Second and Park Avenue is Smith's Store. After the Klemp Hotel burned down, the Mukilteo Garage was constructed. (Courtesy of the Mukilteo Historical Society.)

Capt. Nathaniel B. Fowler was the brother of Jacob Fowler, one the founders of Mukilteo. Born in 1832, Nathaniel enlisted in Company K of the New York Militia as a 2nd Lieutenant on May 6, 1861, less than a month after the beginning of the Civil War. He served with distinction and was mustered out as a captain in Elmira, New York, on May 22, 1863. After the war, Nathaniel made the cross-country journey to Mukilteo, where he purchased property near the trading post of his brother Jacob. However, his life was cut short when he drowned while trying to secure his sloop during a fierce winter storm. In his prime at age 41, friends and family mourned Nathaniel before burying him in Mukilteo's Pioneer Cemetery. (Courtesy of the Mukilteo Historical Society.)

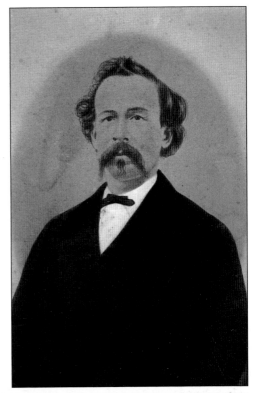

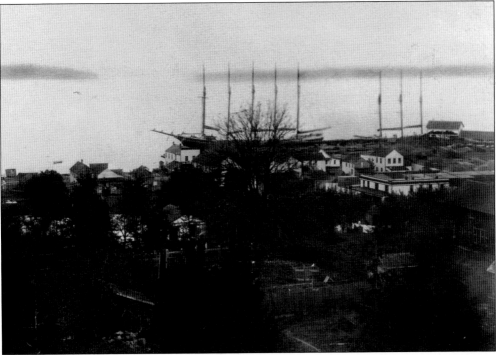

People struggled during the Great Depression. However, by this time, at least people had the convenience of indoor plumbing. (Courtesy of the Mukilteo Historical Society.)

Dr. Claude Chandler (1881–1938) was the first doctor in Mukilteo. A graduate of Williamette University, he had a private practice in Mukilteo and Whidbey Island, operated the Chandler Drugstore, and served as doctor of Rosehill School and Crown Lumber Company. He was also a member of the board of directors for Rosehill School. According to his daughter Jo-An (Chandler) Cannon, "My father always carried candy in his pocket." Carrol Smith (1891–1982) moved from Missouri to Mukilteo with her family in 1905. Carrol's parents were owners of the N. J. Smith Store. She attended Rose Hill School and graduated from Everett High School. She and Claude married in 1910. In addition to taking care of the family, Carrol managed the Chandler Drugstore. (Courtesy of the Mukilteo Historical Society.)

Located on Fifth Street and Loveland Avenue, the LaBeau house was built around 1911. Louie and Kate LaBeau lived in the house with their three children Malcolm, Madeline, and Kathleen. Malcolm was the first paperboy in Mukilteo. The house is still owned by the LaBeau family today. (Courtesy of Renee Ripley.)

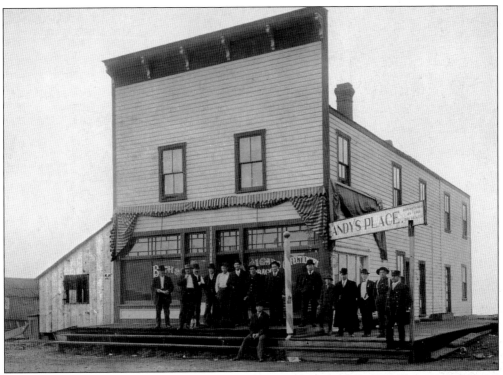

Andy's Place, originally called the Bodega Saloon, was located on Park Avenue and Front Street. Across from the Saratoga apartment building, Andy Nelson owned the saloon. Louie Andersen, who worked for Nelson, later purchased the property. He built a new saloon near the post office on Park Avenue. Those pictured include, from left to right, Mr. Jackson, Hans Radman, Henry Swartz, Lawrence Hurd, Joe Zahler, Andy Nelson, John Carlson, Ed Bemis, Floyd Haines, Martin Andersen, Big Oscar, Louie Andersen, Henry Andersen, and two unidentified. (Courtesy of the Mukilteo Historical Society.)

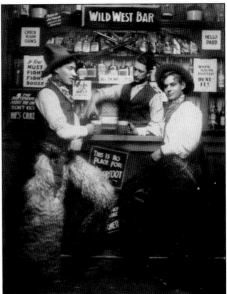

Taken in a saloon on Front Street, this postcard from the early 1900s portrays Walter Riches and Squig Cavanara dressed up as cowboys. (Courtesy of the Mukilteo Historical Society.)

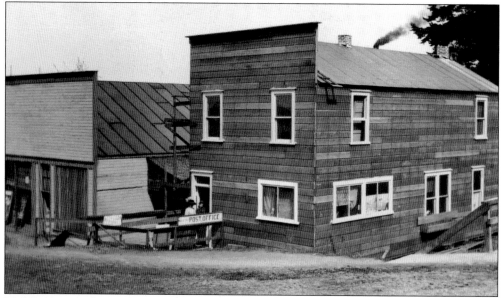

Mukilteo's second post office was built in 1912. Located on Park Avenue and Second Street, Helen Hadenfeldt was the postmistress. The Hadenfeldts lived above the post office. They also owned the theatre. Laura Gear, who worked for the post office, would collect the mail from the railway depot. She would push it up Park Avenue in a wooden wheelbarrow to the post office. Then the mail was separated for delivery or pick up. (Courtesy of the Mukilteo Historical Society.)

Members of the Foster family, owners of the Bayview Hotel, pose for a picture in early Mukilteo. Kate (Foster) LaBeau is holding the rifle. (Courtesy of Renee Ripley.)

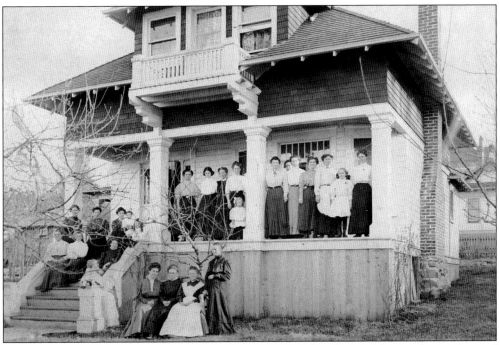

This photograph of the Ladies Aid of the Presbyterian Church was taken in front of one of Mukilteo's early homes. At the time, Edith Ball lived in the house on Second Street and Lincoln Avenue. She is wearing a white apron and is seated in front of the house. Standing on her left is Louisa Fowler Sinclair. Others in the picture include Agnes Foster Schlotman, Mrs. Foster, Mrs. Camp, Mary Keys, Mrs. McBeth, Mrs. Coulter, Verna Young, Byrdie MacBeth Taro, Laura Gear, Mrs. Gould, and Mrs. Amundson. The house was demolished when the National Bank of Commerce was built in 1964. (Courtesy of Mukilteo Historical Society.)

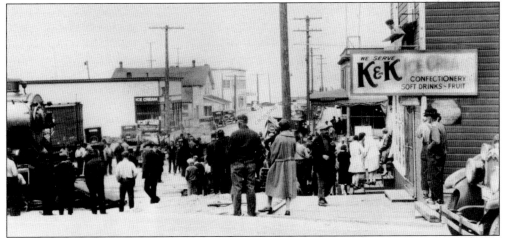

Beverly (Dudder) Ellis remembers, "Brennan's Store was located near the railroad tracks on Park Avenue. The train often rumbled past and shook the building. Anyway, the store had a large, glass display case. It was full of merchandise. I remember the penny candy. We were poor so we rarely bought something. That didn't stop us from looking. The glass was streaked with the finger and nose prints of kids!" John Patrick Brennan (1863–1928) opened his store in Mukilteo in 1905. (Courtesy of the Mukilteo Historical Society.)

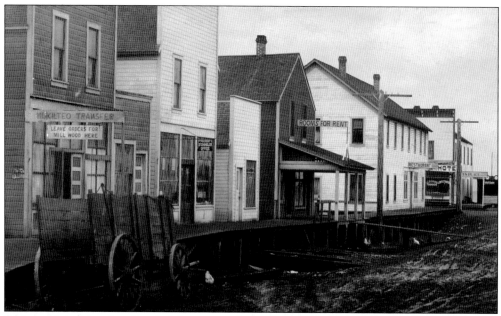

Because high tides often flooded the streets, the early town was constructed high enough above ground to allow water to flow beneath the buildings. The ebb and flow of water was a part of life in early Mukilteo. (Courtesy of the Mukilteo Historical Society.)

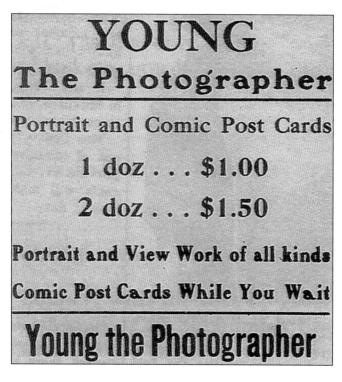

Robert J. Young was born on May 26, 1884, in the town of Cresco, Iowa. While a child, he moved to Everett. While living with his mother in 1908, Young began his career as a photographer. He formed a partnership in Everett with W. F. Morrison (1896–1988) and they opened Home Portrait Studios. Though the partnership dissolved in 1925, Young continued to operate the studio with his wife, Verna (1902–1986), an award-winning portrait photographer in her own right. They operated the studio until 1949. Young took many early photographs of Mukilteo. He died in Everett on November 6, 1951. (Courtesy of the Mukilteo Historical Society.)

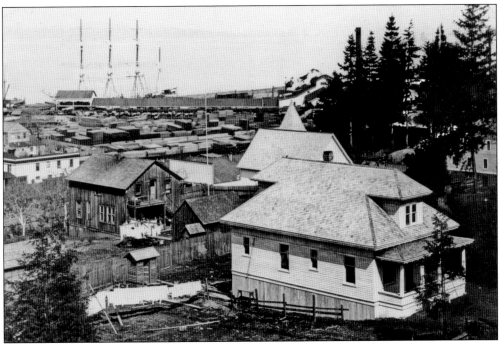

This picture shows the McDonald house on Third Street. In the early 1900s, people had an outhouse in their backyards, and sewage drained into Possession Sound. (Courtesy of the Mukilteo Historical Society.)

This photograph portrays, from left to right, Ronald, Merle, and Bill Kane seated on an old Model T Ford. Ronald Kane served as mayor of Mukilteo from 1964 to 1969. (Courtesy of the Mukilteo Historical Society.)

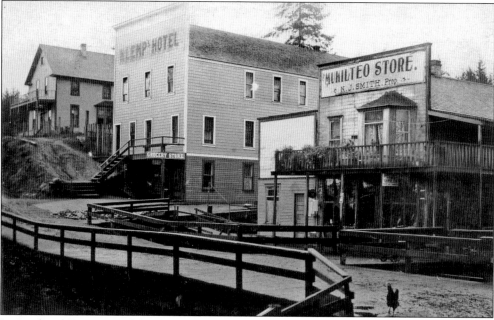

Located near Brewery Gulch, Klemp Hotel and the Mukilteo Store sat near the corner of Second Street and Park Avenue. (Courtesy of the Mukilteo Historical Society.)

This photograph shows Mr. Brennan with his team and wagon, which used to haul heavy items in the early days. Brennan owned a confectionery close to the train depot. At the time, the only transportation to Everett was by boat or train. Mr. Brennan helped transport goods in Mukilteo. Della Olin, seen above, is the little girl dressed in white in the front of the wagon. Her mother, Mary Laabs, is standing toward the back. Standing beside the wagon is Louie Laabs. Della's sister is sitting on her uncle's lap in the foreground. (Courtesy of the Mukilteo Historical Society.)

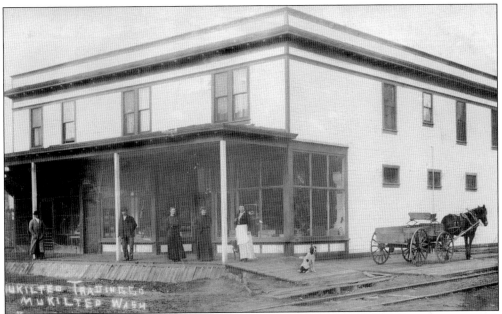

According to Tude (Zahler) Richter, "The Crown Lumber Company Store was located near the railroad tracks on Park Avenue. My uncle, Otto Zahler, operated the store. It was general mercantile, so they carried everything—food, clothing, pots and pans. People kept a tab for merchandise. They paid their bills monthly. Goods came and went by delivery wagon." (Courtesy of the Mukilteo Historical Society.)

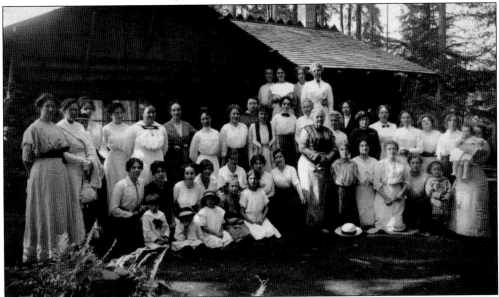

Located on the corner of Fifth Street and Park Avenue, Balls Park or Greenwood Park (as it was also known) was a popular attraction. Because transportation was limited, many people sought local recreational opportunities. Situated in a rustic setting, the park rented cabins. Developed by Mr. H. O. and Luella Ball in the early 1900s, the beautiful park was a favorite picnic sight with families who gathered to share food and good times. (Courtesy of the Mukilteo Historical Society.)

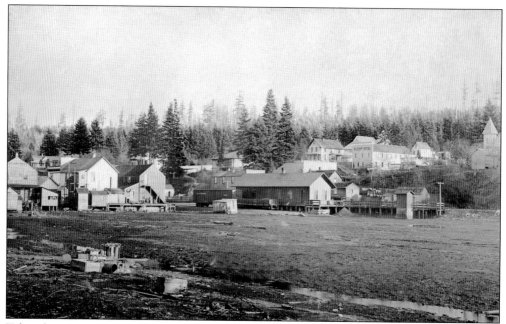

Taken from Front Street, this photograph shows the backside of the train depot where the trains switched tracks. Notice the outhouse, swamp, Nazarene church, and Klemp Hotel. (Courtesy of the Mukilteo Historical Society.)

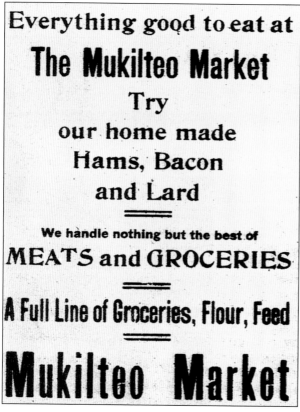

Everything good to eat at
The Mukilteo Market
Try
our home made
Hams, Bacon
and Lard

We handle nothing but the best of
MEATS and GROCERIES

A Full Line of Groceries, Flour, Feed

Mukilteo Market

The Mukilteo Market provided a fresh supply of fruits, vegetables, and meats. During the commercial fishing season, local gillnetters and purse seiners supplied fresh salmon, clams, and crabs. Because many families had their own vegetable gardens and smokehouses, there were always canned goods and processed meat and fish. Families preserved their perishable items in root cellars. This ad ran in the *Mukilteo Enterprise* on February 18, 1909. (Courtesy of the Mukilteo Historical Society.)

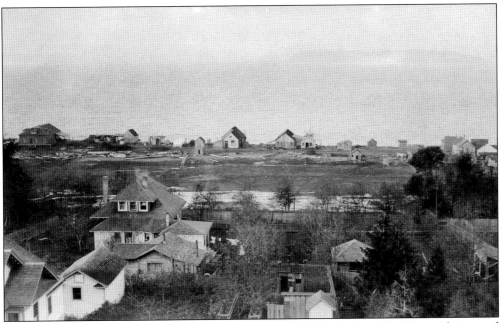

Looking west toward Possession Sound from Third Street, one can see the Losvars' home and houses along the waterfront prior to a ferry dock being built on Front Street. (Courtesy of the Mukilteo Historical Society.)

Pelagia (pictured here) and Frank Pokswinski came to Mukilteo from Perham, Minnesota, in 1906 with their four children Celia, Florian, Clara, and Helen. Three more children, Delia, Paul, and Angie, were born in Mukilteo. Frank worked as a stationary engineer at Crown Lumber Company. (Courtesy of the Mukilteo Historical Society.)

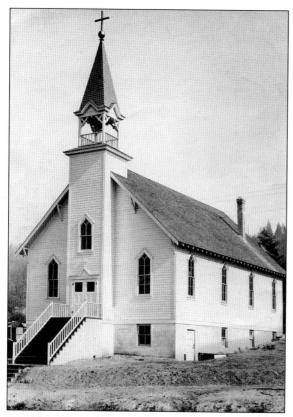

Missionary fervor to Christianize the west can be attributed to an incident that occurred in 1831. That year, four Native Americans (possibly Nez Perce) traveled west of the Rockies to St. Louis to meet with explorer William Clark (1770–1838), then superintendent of Indian affairs. The Native Americans wanted to learn more about the white man's religion. Both Catholics and Protestants interpreted this as an opportunity to send missionaries to the Northwest. This photograph shows Mukilteo's Saint John's Catholic Church, which was constructed in 1919. (Courtesy of Marie [Josh] Kaiser.)

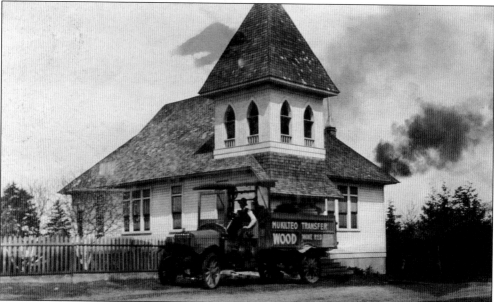

The early town of Mukilteo had four churches: the Nazarene (1916) was on Second Street, while the Christian Missionary Alliance (1915), the Presbyterian (1907), and the Catholic church (1919) were all located on Third Street. This photograph shows Archie Sherar delivering wood from Crown Lumber Company to the Presbyterian church. (Courtesy of the Mukilteo Historical Society.)

Located on Second Street and Park Avenue, this picture is of the Nazarene church. (Courtesy of the Mukilteo Historical Society.)

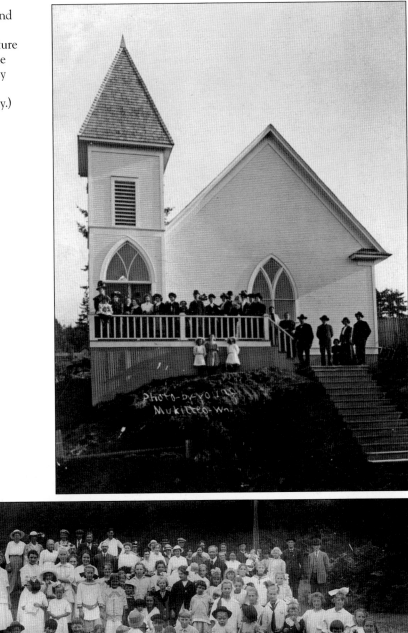

In this early-1900s photograph, members of Mukilteo's Presbyterian church are holding a Sunday school picnic. (Courtesy of the Mukilteo Historical Society.)

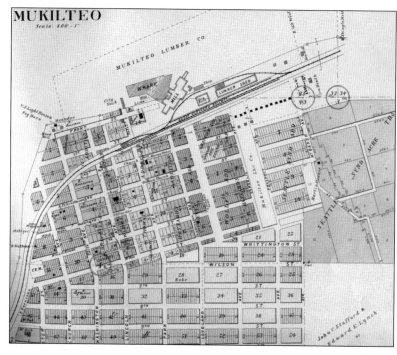

Produced by the Sanborn Map Company, this sketch illustrates Mukilteo in 1926. At the time, Mukilteo had a population of 500 inhabitants. In the early days, Mukilteo's Old Town extended from Front Street to Fifth Street, and the Pioneer Cemetery to Japanese Gulch. (Courtesy of the Everett Public Library.)

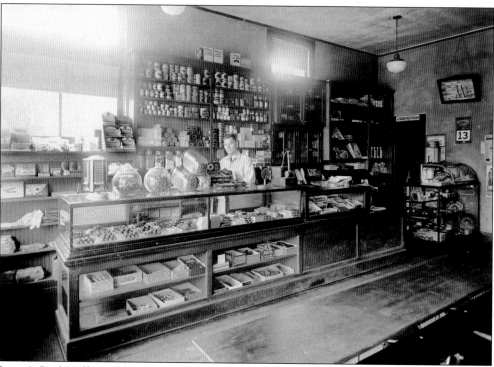

Louie's Pool Hall was located on Park Avenue and Second Street. Louie Andersen was the proprietor. Men gathered in the back room to play pool and cards. They also sat on a bench in front of Louie's and talked and smoked. The Nazarene church was across the street. (Courtesy of the Mukilteo Historical Society.)

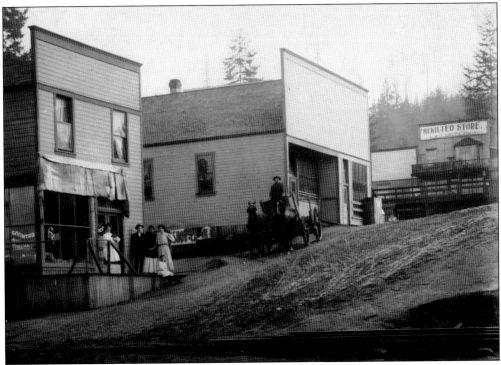

The first building on the left was Brennan's store. Catherine Isabel Brennan is one of the ladies standing in front of the store. The other buildings were a saloon, dance hall, and theater. At the time, N. J. Smith ran the Mukilteo store up the hill. The Klemp Hotel was located next to the Mukilteo Store. (Courtesy of the Mukilteo Historical Society.)

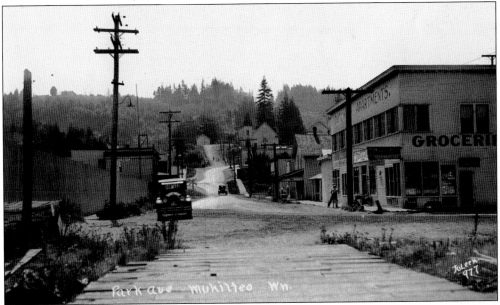

Dutcher's Apartments (later the Saratoga) boarded many of the female teachers at Rosehill School, including Mary Lou Morrow. Women were allowed to teach so long as they remained unmarried. (Courtesy of the Mukilteo Historical Society.)

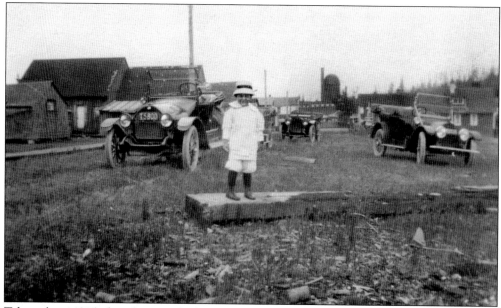

Taken about 1915, this photograph shows Alden Losvar standing on Front Street with Crown Lumber Company in the background. (Courtesy of the Mukilteo Historical Society.)

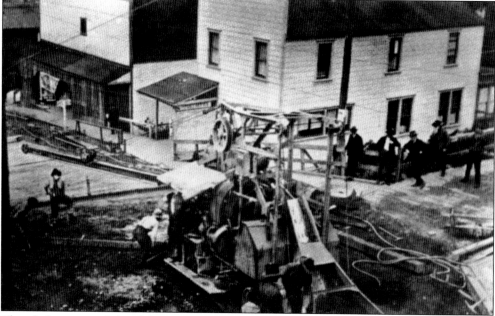

The whole town got behind the paving of Park Avenue. With no city government, town folk had to work together for any improvements to the community. This meant pitching in and sharing labor and cost. Park Avenue was a busy road in Mukilteo's Old Town. At the time, it was the main thoroughfare through town. (Courtesy of the Mukilteo Historical Society.)

Prior to World War I, vehicle transportation wasn't available between Everett and Mukilteo. With winding coastline, hills, and seven gulches to span, the terrain was simply too rugged. Prior to the road, most people traveled between the two towns by rail or boat. For a road, seven wooden bridges were required between Forest Park and Mukilteo. Talk of a road between Everett and Mukilteo dated back to 1861 when the county was formed. This photograph shows the construction of one of those bridges. (Courtesy of the Everett Public Library.)

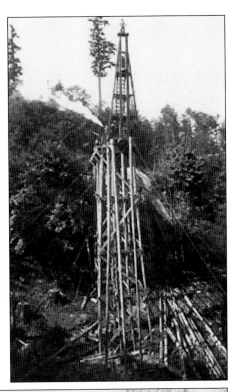

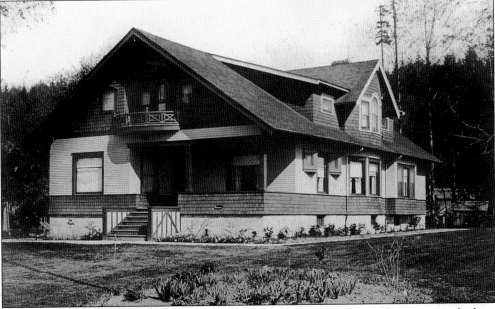

In the early 1900s, Charles and Isabelle McNab purchased 12 acres of wooded property overlooking Puget Sound and built a 4,700-square-foot craftsman bungalow-style house. The interior of the house contained elaborate woodwork, including gingerbread trim. Materials for the house were brought on barge from the Crown Lumber Company. According to the *Everett Daily Herald* in 1928, the estate and grounds were described as the "showplace of Puget Sound." (Courtesy of Kay Scheller.)

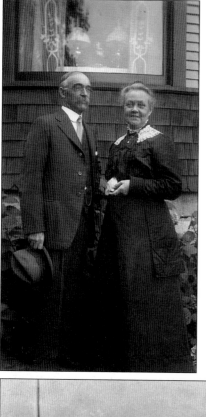

Charles McNab worked for Dr. Chandler, who owned the Mukilteo Drug Store. Isabelle McNab wrote poetry. Both McNabs taught Sunday school at the Presbyterian church in Mukilteo. (Courtesy of Kay Scheller.)

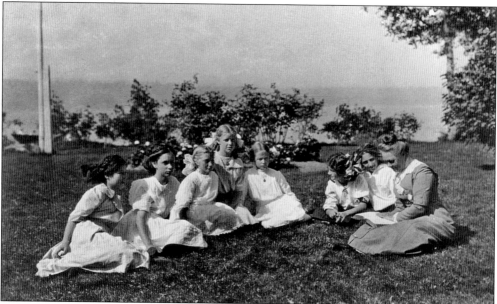

In 1926, the Ursuline Sisters of Montana purchased the property. They used the McNab house as a convent. The nuns would often stroll the grounds during their afternoon prayers. In 1927, Virginia Layton, a 17-year-old from Mukilteo, joined the order and became Sister Marguerite Teresa. During World War II, the army used the property as a hospital. The house was then purchased by Everett and Valeria Hogland of Hogland Transfer Company in Everett. (Courtesy of Kay Scheller.)

For over 60 years, the house has been in the hands of the Hogland family. Today the old manor home has been restored to its original charm. Kay (Hogland) Scheller operates the establishment as a bed and breakfast. In 1992, the estate was placed on the Register of Historic Places. (Courtesy of Kay Scheller.)

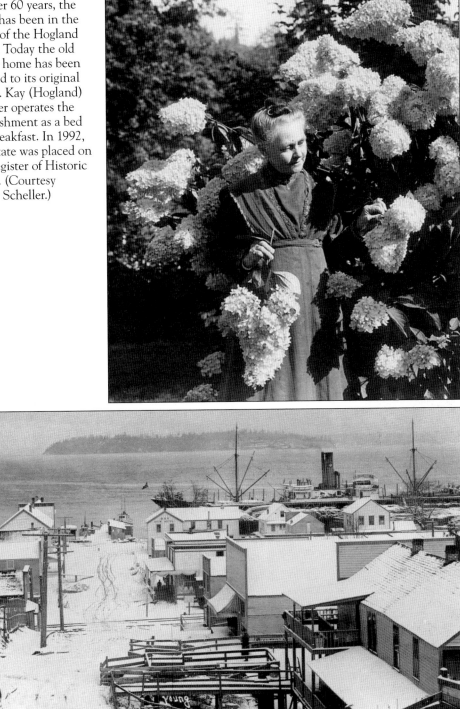

This winter scene in this photograph was taken looking down Park Avenue toward the bay. It was 1916—the year of the "big snow." Notice the bridge walkways leading to the entrance of the Mukilteo Store. Hat Island is in the distance. (Courtesy of the Mukilteo Historical Society.)

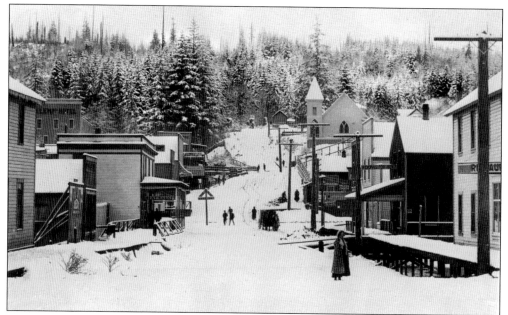

Facing east from the bay, this early photograph of Mukilteo's Old Town shows locals on Park Avenue after snowfall. Beyond the railroad tracks, one can see the Nazarene church and forested hillside. (Courtesy of the Mukilteo Historical Society.)

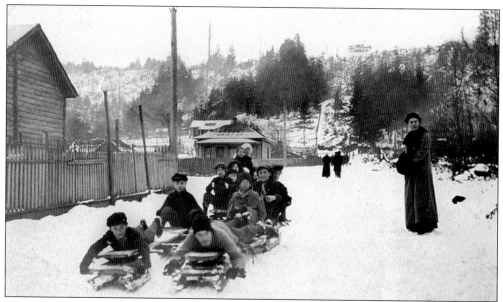

The hill on Fifth Street and Loveland Avenue provided great sledding. Included in this picture are Hattie Hadenfeldt, Viola Schrader, John Goralski, Steven Brodniak, Mervale McClure, Delia Pokswinski, and Florian Pokswinski. (Courtesy of the Mukilteo Historical Society.)

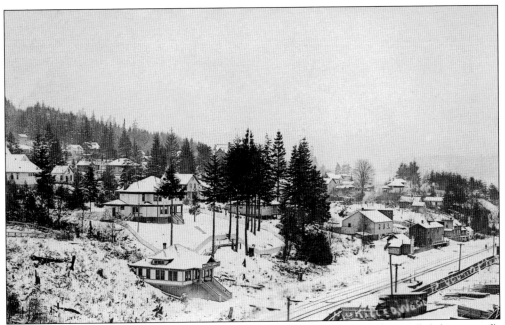

This scene shows the Crown Lumber Company office and Arthur Scott's house (left foreground). Scott was the general manager of Crown Lumber Company. The property was fenced and neatly maintained by a Japanese gardener by the name of Kanjiro Wakabayashi. (Courtesy of the Mukilteo Historical Society.)

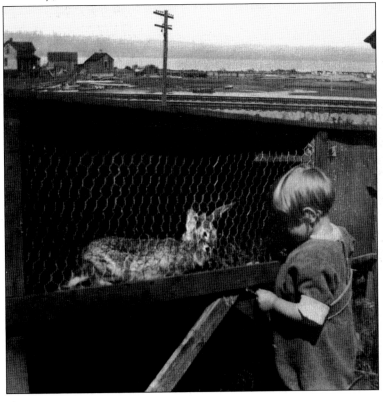

A young Marie (Josh) Kaiser stands in her yard near the rabbit hutch with Mukilteo's waterfront town, Possession Sound, and Whidbey Island in the distance. (Courtesy of Marie [Josh] Kaiser.)

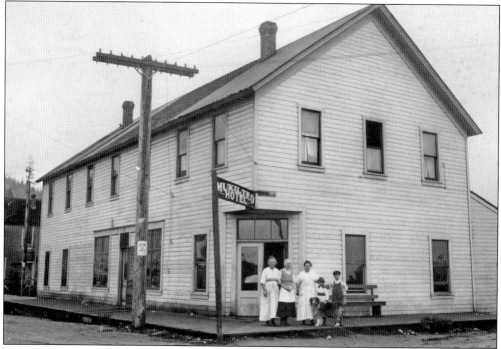

Located on Front Street and Park Avenue, the Mukilteo Hotel was a popular establishment prior to the 1920s. The building was originally constructed in 1906. It was called Smith's Hotel. By 1911, the name changed to Butler Hotel. Changing hands many times, the hotel became known as the Mukilteo Hotel, and then Sherar's. In the 1920s, the building became Dutcher's Apartments. Later it was called the Saratoga Apartments. (Courtesy of the Mukilteo Historical Society.)

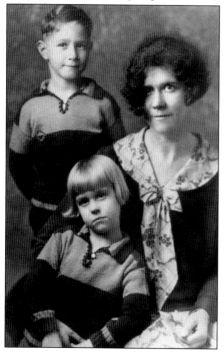

Taken in 1930, this photograph shows Peggy Zahler with her children, Sylvia (Tude) and Robert. Peggy taught at the first Rose Hill School. She was married to Joe Zahler, who worked at the Crown Lumber Company Store. Tude and Robert were born in their home on Fifth Street (near the liquor store). Dr. Chandler delivered both children. Robert spent 32 years as a chief engineer in the Merchant Marines. (Courtesy of Tude [Zahler] Richter.)

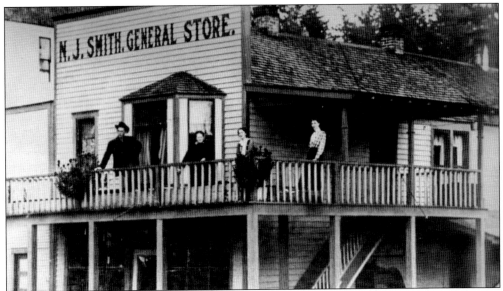

This early store was owned and operated by N. J. Smith. The photograph shows N. J. Smith, Mrs. Smith, Carol Chandler, and Caroline Bailey. The upper floor was their home, while the general store was located at street level. The N. J. Smith General Store would eventually become the Mukilteo Store. (Courtesy of the Mukilteo Historical Society.)

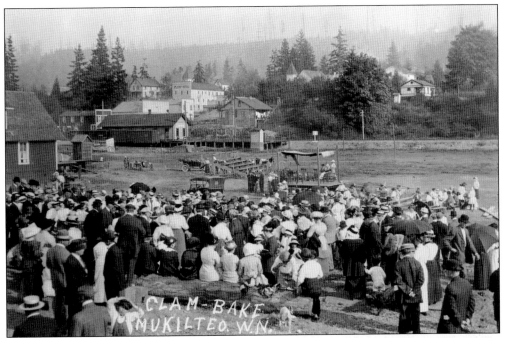

Dubbed the "Mukilteo Road Celebration," this clambake took place August 5, 1914, on the baseball field. It celebrated the completion of a road between Mukilteo and Everett. The house in the foreground on the left belonged to Victor MacConnell. In the background is the roof of the Nazarene church, Dr. Chandler's house, Brennan's Store, and the Klemp Hotel. (Courtesy of the Mukilteo Historical Society.)

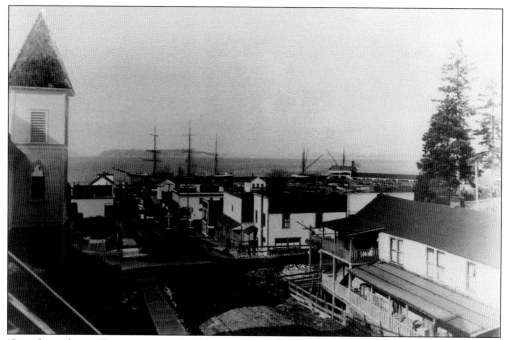

"It is desired to call attention to the following lots, blocks and acreage tracts offered for sale by me at this time. For sale on cash or easy terms: The interest is just as desirable as the cash: Lots near Mr. Chapman's place, overlooking water and easily cleared, $35.00 to $75.00 per lot. Lots laying (sic) back of schoolhouse and along the hill toward Mr. McNab's place, price from $12.50 to $45.00 per lot. Blocks vacated and unvacated, varying in number of lots included in block, from 11 to 34 lots per block, and in area from ½ to 3 acres, prices range from $100.00 to $500.00 per block; many of these blocks are excellent in soil, lay of ground and splendid outlook over the bay, and can be easily approached by present roads, from depot, church and school; will take a small payment down and the balance on easy monthly payments." This advertisement is from the Mukilteo Land Company's real estate brochure. (Courtesy of the Mukilteo Historical Society.)

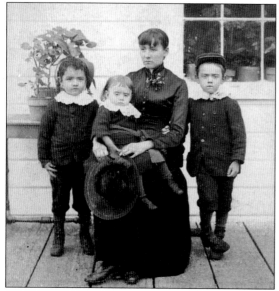

This photograph taken around 1888 portrays Louisa Fowler Sinclair with her children, Dan (left), born March, 20, 1883; Stewart (right), born January 24, 1885; and Cora (seated on her lap), born November 19, 1886. Louisa, daughter of Jacob and Mary Fowler, was the first settler child born in the county. She was of mixed white and Native American ancestry. Interestingly, Mary Warren's father, General Warren, or S'deh-ap-kan, was one of the treaty signers for the Skagit people at the 1855 signing of the Point Elliott Treaty. (Courtesy of the Mukilteo Historical Society.)

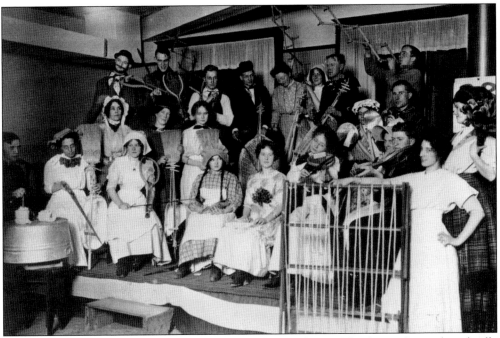

H. G. Hadenfeldt was owner and manager of the Mukilteo Theatre. The theater featured vaudeville acts, silent movies, and local entertainment. Film stars like Rudolph Valentino, Lillian Gish, Buster Keaton, Mary Pickford, and W. C. Fields graced the movie screen. For 10¢, you could see a picture show like D. W. Griffith's *The Birth of a Nation* (1915), Rex Ingram's *The Four Horsemen of the Apocalypse* (1921), or Charlie Chaplin's *The Gold Rush* (1925). Seen here, a theater group made up of local town folk provides entertainment. (Courtesy of the Mukilteo Historical Society.)

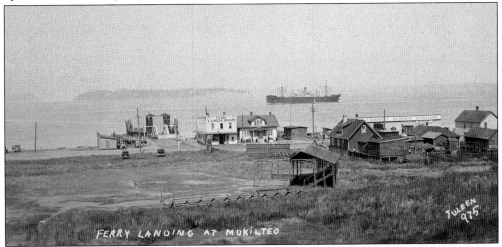

Baseball was very popular in Mukilteo. In the early days, the dream of every boy in town was to play baseball for Mukilteo. The games often drew large crowds. It was not uncommon to load one's truck with people and travel to away baseball games. The main competition came from teams in Snohomish County. However, one year a passenger boat took players and fans to Bremerton to play a navy team, and Fort Casey to play the army. The game that typically drew the largest crowds at Mukilteo featured Port Angeles—the other Charles Nelson Company sawmill location. (Courtesy of the Mukilteo Historical Society.)

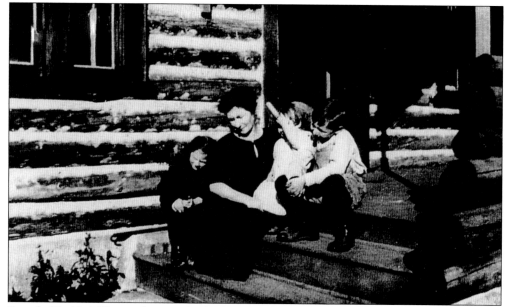

Beverly (Dudder) Ellis was born in this log house at the end of Third Street (near Japanese Gulch) on February 21, 1920. The pioneer house was made of Douglas fir logs brought down by horse and wagon from the hillside above Mukilteo's Sixth Street. Beverly's father, James Walter Dudder, who worked for Crown Lumber Company, built the house. The Dudders lived in the house from 1920 until 1962. Pictured from left to right are Maralyn, Beverly's mother, Hazel; Beverly; and Creighton Dudder. (Courtesy of Beverly [Dudder] Ellis.)

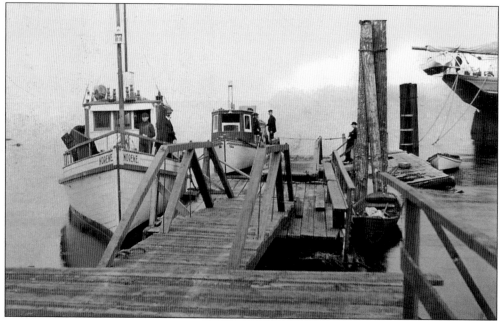

The *Noreen* was skippered by Howard Josh, who also ran the Eagle Lunch. Later it became the Ferry Lunch Room, Taylor's Landing, and finally Ivar's. Though the name has changed, the restaurant has always combined great clam chowder with a spectacular view. (Courtesy of the Mukilteo Historical Society.)

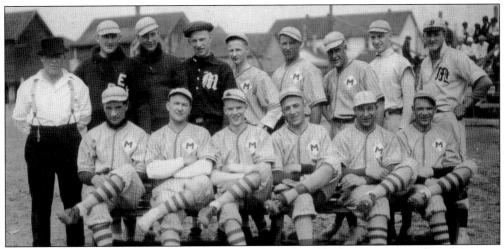

This photograph of the 1921 Mukilteo baseball team shows manager Howard Josh at left. From left to right are (first row) Dutchie Davis, Henry Hall, Harold Rulien, Johnie Brodniak, Frankie Brodniak, and unidentified; (second row) Buck Weaver, Ray Reiken, Elmer Dudder, Earl Reiken, Phil Goralski, Rex Donovan, Harvey Reiken, and Bill Jensen. Some people believe this is the same Buck Weaver who played third base for the Chicago White Sox in 1919, and, along with seven teammates (including "Shoeless" Joe Jackson) was banned from organized baseball for his involvement in fixing the World Series. (Courtesy of the Mukilteo Historical Society.)

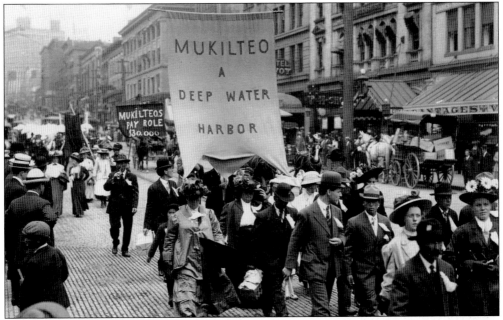

Seattle's Alaska Yukon Pacific Exhibition (AYP) took place from June 1 to October 16, 1909. Held on the University of Washington campus, the event was dubbed "Seattle's Grand World's Fair." Over four million people attended, and the event raised $10 million. The exhibition put Seattle on the map as a gateway to the Pacific Rim. The fair featured "Special Days," focused on various communities. Seen above, people from Mukilteo march in a parade in downtown Seattle. They are holding signs that read, "Mukilteo's Pay Role $30,000" and "Mukilteo, A Deep Water Harbor." (Courtesy of the Washington State Historical Society.)

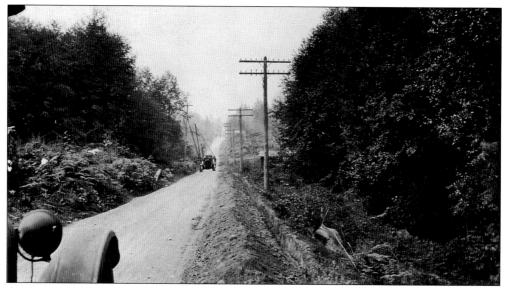

On August 5, 1914, the road connecting Mukilteo and Everett officially opened. Hundreds of Snohomish County citizens traveled to Mukilteo to participate in the celebration. County pioneers Alexander Spithill (1824–1920), who had homesteaded the land that became known as "Japanese Gulch"; Louisa Fowler Sinclair (1862–1955), daughter of Jacob and Mary Fowler; and William Whitfield, Snohomish Country historian, greeted visitors. (Courtesy of the Mukilteo Historical Society.)

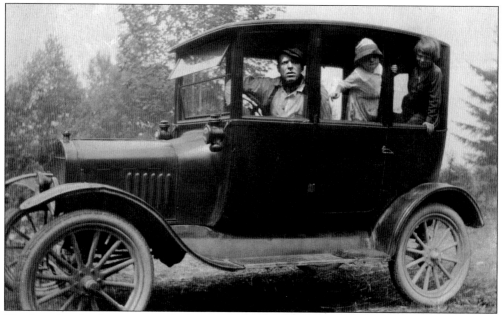

The American landscape was vastly changed by the invention of the automobile. Rural communities were linked by construction of paved roads. New homes came equipped with a garage and driveway. Gas stations, public garages, and repair shops emerged. Traffic signals were installed on street corners. Roadside stands, featuring food, beverages, and other items sprang up overnight. Families who had previously been isolated could now freely travel about the country. Gas cost 25¢ per gallon. (Courtesy of Marie [Josh] Kaiser.)

This photograph shows a very young Bill Kane. As an adult, Kane worked for the Great Northern Railroad until he was injured. Following his accident, he helped people in Mukilteo with various construction projects. (Courtesy of the Mukilteo Historical Society.)

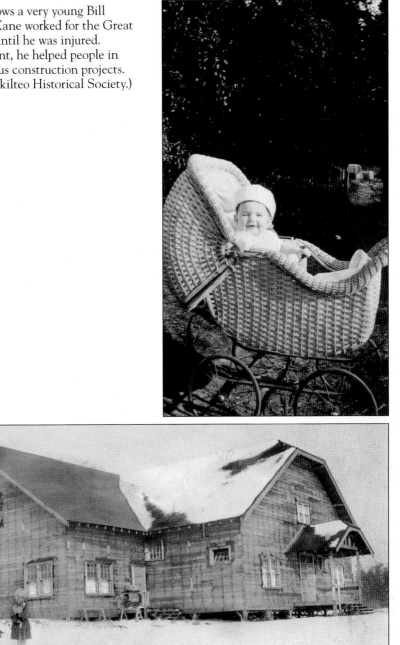

Originally constructed in the early 1920s, this building was formally named Hawthorne Hall at its grand opening in 1925. It became the gathering place for town meetings and community events. Women raised the money and men volunteered the labor on evenings and weekends. Because of their work schedules at the mill, the building took five years to finish. It included a kitchen, stage, side rooms, and large dance floor. Constructed of Douglas fir, the building was also called the Royal Neighbors Hall. Today the building serves as the Boys and Girls Club. Thelma (Weers) Kane is standing in front of the building. (Courtesy of the Mukilteo Historical Society.)

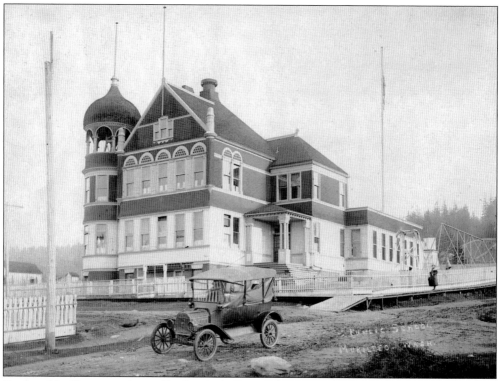

Designed by Everett architect Frederick A. Sexton (1842–1930), Rose Hill School (originally spelled as two words) was completed in 1893. (Courtesy of the Mukilteo Historical Society.)

According to the book *Snohomish County in the War*, Mukilteo's Honor Roll, those who enlisted in World War I included Wilber E. Boyle, Clarence J. Brennan, Andrew H. Brodniak, Charles Christiansen, Emil T. Christiansen, Perry Christiansen, Albert L. Davis, Ernest B. Davis, Nila A. Ebert, Myron E. Ford, Stanley Goralski, Charles D. Jones, M. F. Jones, R. A. Jones, Frank Lewis, Charles LeBeau, Bjorn H. Moe, Walter A. Riches, Rocco Santoro, Ezra Van Valkenburg, Willis D. Wetstein, and Joe Zahler. (Courtesy of the Mukilteo Historical Society.)

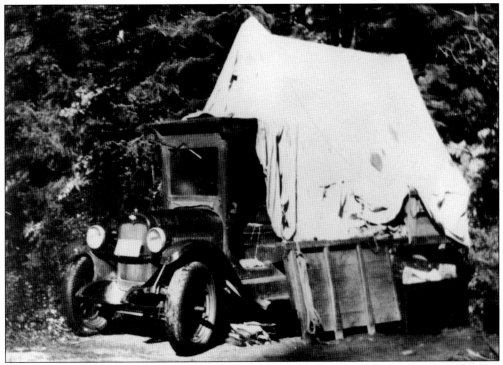

Victor "Old Mac" McConnell, who operated the service station where the Sea Horse Restaurant once stood, is credited with constructing the first camper in Mukilteo. (Courtesy of the Mukilteo Historical Society.)

Taken in 1926, this photograph shows, from left to right, Bill, Merle, and Ronald Kane in front of their house in Mukilteo. (Courtesy of the Mukilteo Historical Society.)

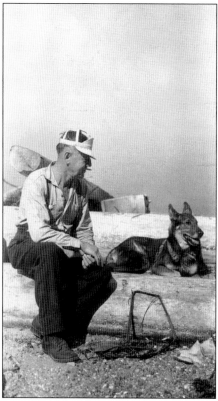

This photograph shows Dan Sinclair with his German shepherd at Mukilteo beach. Sinclair, a grandson of J. D. Fowler, was a logger in the days when a man had to swing an ax to fell trees. Louisa Fowler married Dan Sinclair in 1882. They had six children, consisting of three girls and three boys. Long-time Mukilteo resident Frances Record was one of those children. Dan Sinclair was critically injured in a logging accident when he was 66 years old. (Courtesy of the Mukilteo Historical Society.)

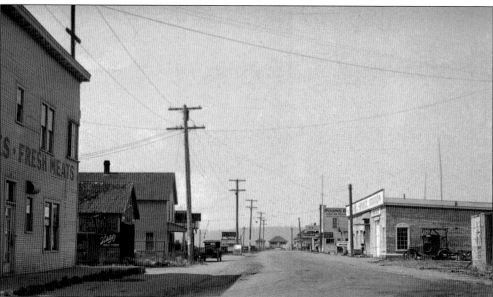

This photograph was taken facing north on Front Street. To the left is Victor McConnell's boathouse. Built of beach sand and cement in the 1920s, his gas station sits across the street. On the side of the boathouse stands McConnell's old Model T. The automobile provided the power for the cement mixer that was used to build the boathouse. (Courtesy of the Mukilteo Historical Society.)

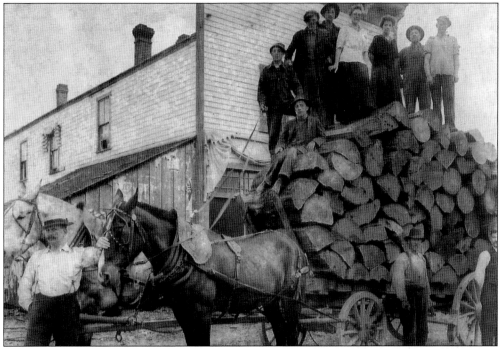

Fuel wood was available for purchase from Crown Lumber Company. These blocks of wood were cut from trimmings at the mill. Wood was delivered to homes and businesses by horse and wagon. (Courtesy of the Mukilteo Historical Society.)

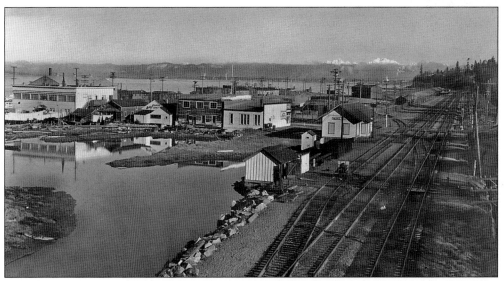

Looking north toward Everett, this photograph shows the lagoon near the train depot at Mukilteo. In the distance looms the Cascade Mountain Range. (Courtesy of the Mukilteo Historical Society.)

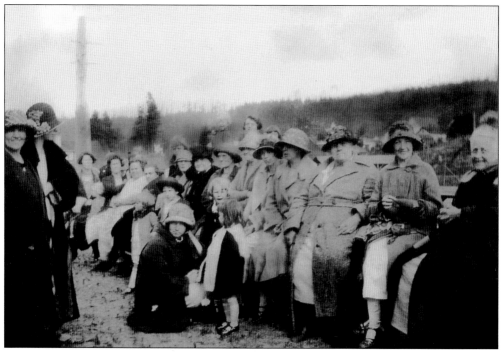

This photograph shows the Presbyterian Church Guild at Mukilteo beach around 1927. The beach was a favorite gathering place for various groups. (Courtesy of the Mukilteo Historical Society.)

Town founder J. D. Fowler planted the Fowler pear tree as part of an orchard in 1863. It was planted to honor the birth of his daughter Louisa. The tree continues to bear fruit. A state historical site, the tree stands near the public works building in downtown Mukilteo. (Courtesy of the Mukilteo Historical Society.)

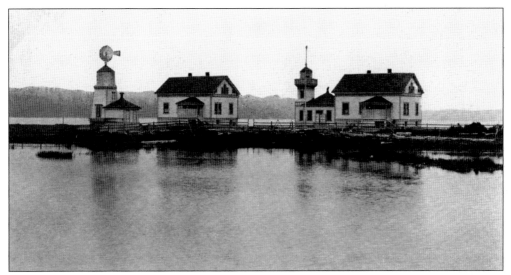

The Mukilteo Light Station began operation on March 1, 1906. Located on the east side of Possession Sound in Puget Sound, the Victorian-style lighthouse was designed by renowned lighthouse service architect Carl W. Leich. The keeper's houses (quarters A and B) were built at the same time, as well as a pump house and windmill. The windmill was used to pump water for the light station in the early days. The cost was $27,000. It was said that Leick's motto was "Build 'em stout and make 'em last." (Courtesy of the Mukilteo Historical Society.)

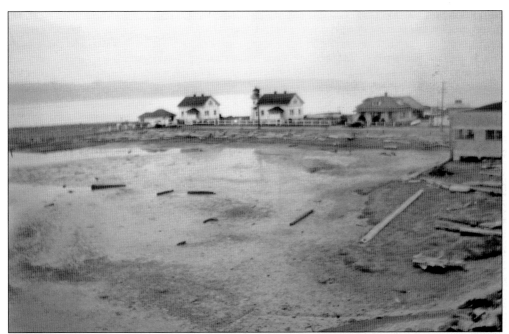

On Friday, March 2, 1906, the *Everett Morning Tribune* reported, "The government lighthouse at Mukilteo flashed its guiding rays for the first time over the dark waters of Puget Sound last night. The light can be plainly seen from almost any favorable point in Everett and dozens of people curiously watched the glimmer of the lamp as it shot its beams of yellow light in the direction of the city at regular five second intervals." (Courtesy of the Everett Public Library.)

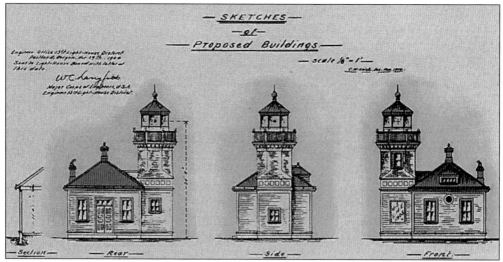

The lighthouse was equipped with a foghorn, rotating lens, and oil lamp. The lamp needed to be refilled every three hours. The present lens is a fourth order Fresnel lens, made in France in 1852. It was brought to Mukilteo when the lighthouse converted to electricity in 1927. The lighthouse became fully automated in 1979. The light sends out a flash sequence of two seconds on and three seconds off, 24 hours a day, with a range of 12 nautical miles, approximately 14 miles. (Courtesy of the Mukilteo Historical Society.)

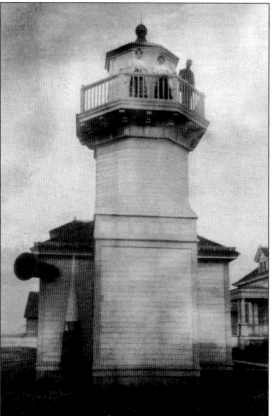

The following is excerpted from the manual *Instructions and Directions to Lighthouse and Light Vessel Keepers, 1871:* "The lighthouse . . . shall be lighted and the lights exhibited for the benefit of mariners punctually at sunset, daily . . . Every evening, half an hour before sunset, the keepers provided with a lighting lamp, will ascend to the lantern of the tower and commence lighting the lamp . . . so that the light may have its full effect by the time twilight ends. Lighthouse lights . . . are to be kept burning brightly, free from smoke . . . during each entire night from sunset to sunrise . . . Light keepers are required to keep a careful watch . . . and see that the lights under their care are kept properly trimmed throughout each night; and during thick and stormy weather those keepers who have no assistants must . . . watch the light during the entire night." (Courtesy of the Mukilteo Historical Society.)

The first light keeper was Peter N. Christiansen, who served from March 16, 1906, when the light was first lit, until his death on October 5, 1925. Note "Christianson" is misspelled in this sketch. (Courtesy of the Mukilteo Historical Society.)

KEEPER CHRISTIANSON

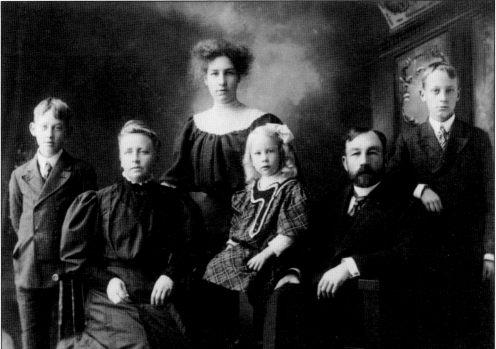

Being close to a good school was important to Peter Christiansen. He and his wife, Theodine, came to Mukilteo with four children. In the above photograph are, from left to right, Perry, age 10; Theodine; Anna, age 18; Clara, age 4; Peter; and Charles, age 12. (Courtesy of the Mukilteo Historical Society.)

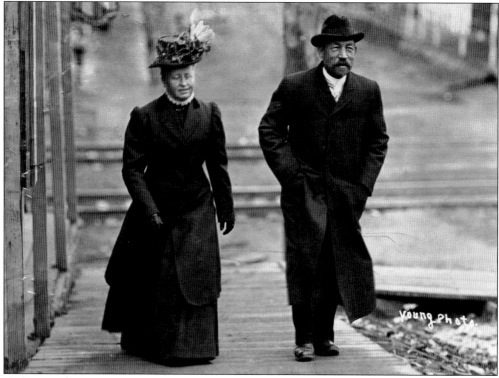

When Christiansen died from an apparent heart attack, Theodine maintained operation of the light station until Edward A. Brooks reported for duty as the second light keeper. This photograph shows Peter and Theodine walking home after attending Sunday church service at the Mukilteo Presbyterian Church. (Courtesy of the Mukilteo Historical Society.)

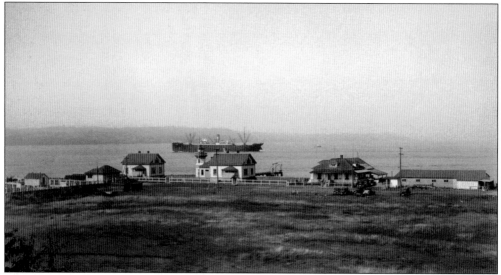

There has only been one time when the lights of U.S. lighthouses were extinguished; that was following the bombing of Pearl Harbor on December 7, 1942. When a U.S. ship sank at the mouth of the Columbia River that night, it was decided it was probably safer to leave the lights on, even with the threat from enemy ships. (Courtesy of the Mukilteo Historical Society.)

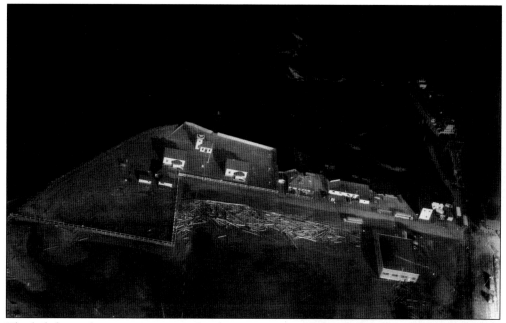

The lighthouse began operation under the U.S. Lighthouse Establishment. The U.S. Coast Guard took over operation of all lighthouses in 1939. In 2001, the U.S. Coast Guard transferred the Mukilteo Light Station property to the City of Mukilteo. (Courtesy of the Mukilteo Historical Society.)

The Coast Guard leased the lighthouse to the City of Mukilteo in 1991. One of the few lighthouses constructed of wood, the Coast Guard continues to maintain the navigational equipment. This article appeared in the *Mukilteo Weekly Mentor* on Tuesday, November 17, 1927. (Courtesy of John Zuanich.)

RUM CHASER LEAVES FOR POST AT PT. TOWNSEND

Coast Guard Station Here Discontinued When Craft Moves

Coast Guard 2229 and its crew, under command of Captain Iverson, has been transferred to Port Townsend for duty. They left Tuesday morning, accompanied by the seventy-five foot chaser 263, which transported the personal belonging of the small boat's crew.

The 2229 has been stationed in Mukilteo for several months and every member of the crew is well known and well liked here, having made many friends.

In the course of duty they will be in Mukilteo occasionally, according to Captain Iverson.

The Coast Guard Station will be out of commission here with the departure of the 2229, and the speed craft will make trips here only in line of duty.

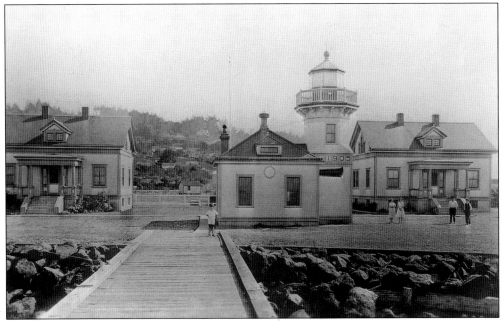

This photograph of the Mukilteo Lighthouse was taken by John A. Juleen (1874–1935), operator of one of Everett's most important commercial photography studios. He produced images of industry, business, portrait, and street scenes in Snohomish County. Using a Kodak Cirkut panoramic camera in 1909, Juleen was one of the earliest photographers to take aerial shots in Snohomish County. Following John's death, his wife, Lena Dalquist, continued ownership of his business until her death in 1955. (Courtesy of the Mukilteo Historical Society.)

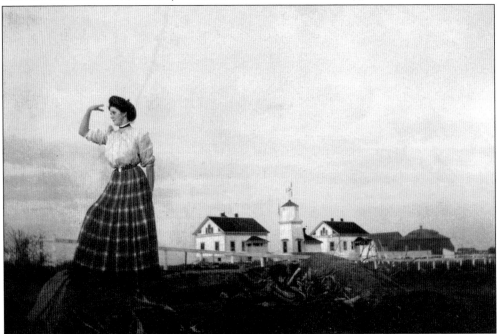

Looking south toward Possession Sound, Jennie Klemp watches a boat make its way around the point. (Courtesy of the Mukilteo Historical Society.)

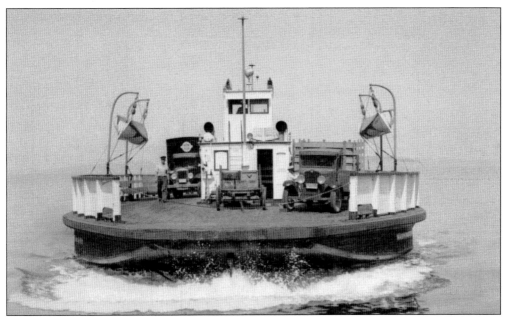

Ferries began to transport goods and people from Mukilteo to Whidbey Island as early as 1911. It wasn't until 1919 they began transporting automobiles. Started in 1928 by Capt. Alexander Marshall Peabody, the Puget Sound Navigation Company operated ferries on Puget Sound. They used the trade name Black Ball Line. At one time, Black Ball Line was the largest privately owned ferry system in the nation. In 1951, the State of Washington began operating the ferry to Whidbey Island. Today more than four million people cross the waters between Mukilteo and Clinton by ferry every year. (Courtesy of the Mukilteo Historical Society.)

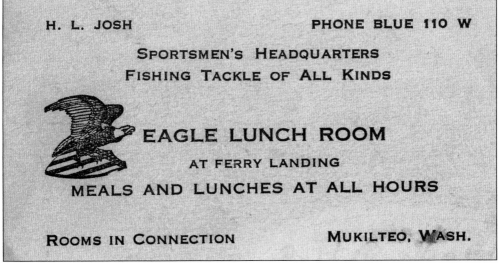

H. L. JOSH PHONE BLUE 110 W

SPORTSMEN'S HEADQUARTERS
FISHING TACKLE OF ALL KINDS

EAGLE LUNCH ROOM

AT FERRY LANDING

MEALS AND LUNCHES AT ALL HOURS

ROOMS IN CONNECTION MUKILTEO, WASH.

Seen above is Howard Josh's business card. Josh, a key contributor to early Mukilteo, operated the tugboat *Tobie* for Crown Lumber Company. Josh, Mildred, and their family lived in the Bayview Hotel. In addition, Josh managed the Mukilteo baseball team and constructed the Eagle Lunch Room, Ferry Luncheon, and baseball field, as well as managed the building of three dikes in Mukilteo. Josh, who was of Irish decent, was well known around town, and people often said, "If you're ever in a fight, you'll want Josh on your side!" (Courtesy of Marie [Josh] Kaiser.)

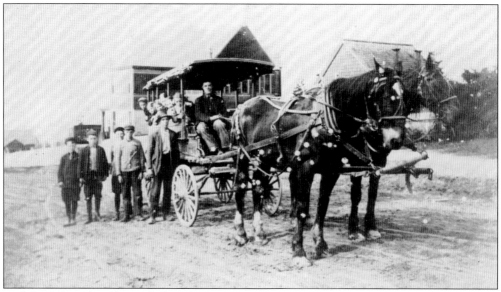

Mukilteo's first school bus picked up the town's children and transported them to the original Rose Hill School. The driver was Roy Weers. The horses' names were Bill and Bird. The students are Frank Wright, Paul Giersch, Frank Weers, Fred Weers, Harry Weers, Art Giersch, Anna Giersch, Alice Weers, Eleanor Weers, and Dorothy Giersch. (Courtesy of the Mukilteo Historical Society.)

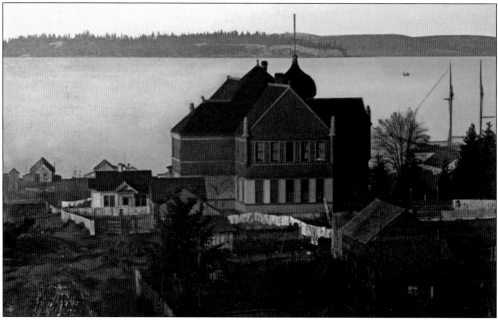

Rose Hill School made front-page news when it burned down on St. Patrick's Day, March 19, 1928. A boy discovered the flames in the early evening, and firefighters thought they were able to save part of the building. About an hour later, the flames kicked back up, destroying the remaining classroom. The building, a total loss, was insured for $40,000. Firefighters believed the fire was caused by a short circuit. Classes for the school's 260 students were moved to churches and the Royal Neighbors Hall. During the fire, there was one last mournful gong from the school bell when it fell from its tower and crashed to the ground. (Courtesy of the Mukilteo Historical Society.)

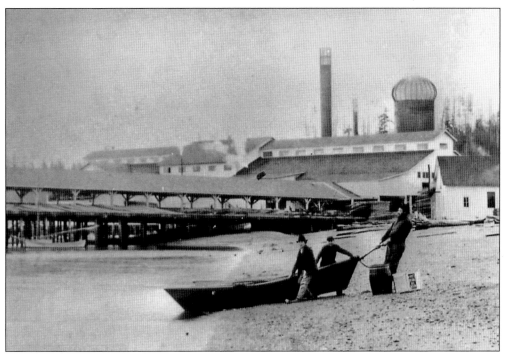

Fishermen pull their boat ashore on the beach at Mukilteo in the 1900s. In the background, one can see the large smokestacks and burner of the Crown Lumber Company. (Courtesy of the Mukilteo Historical Society.)

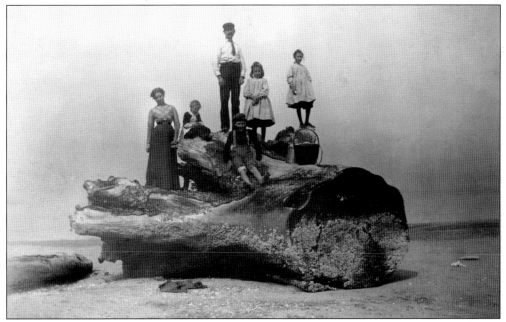

George Vancouver named Possession Sound on June 3, 1792, when he claimed possession of the land for Britain in honor of King George III's birthday. Situated between Everett and Mukilteo, the glacier-carved waters average 48–52 degrees throughout the year. Gedney Island, also called "Hat Island," is located in Possession Sound. (Courtesy of the Snohomish Historical Society.)

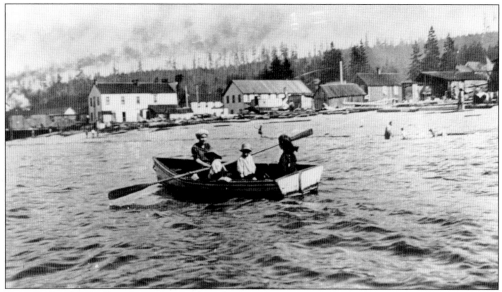

Beverly (Dudder) Ellis claimed, "During the Depression, we were all in the same boat—poor." (Courtesy of the Snohomish Historical Society.)

"Our parents let us go down to the beach and swim so long as we stayed with Alma "Ekie" Ek (second from right)," Jo-An (Chandler) Cannon recalled. "We could play 'til 5:00 p.m. That's when the mill whistle blew. If we didn't mind Ekie, we couldn't go to the beach the next day." Courtesy of the Mukilteo Historical Society.)

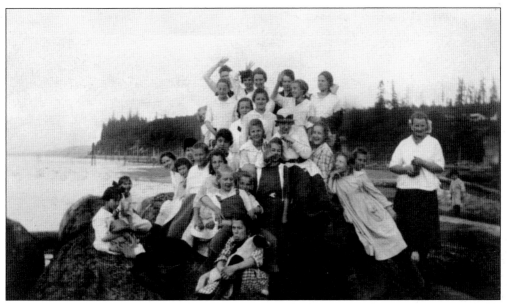

Northern Washington experienced the late Pleistocene glacial period about 28,000 years ago. During this time, an ice barricade formed between the Cascades, Olympic Mountains, and the high divide between Puget Sound and the Chehalis River. Masses of ice reached elevations of 5,300 feet. When the glacier melted huge troughs up to 1,200 feet deep were carved into Puget Sound. This passage of ice left the deep channel known today as Possession Sound. (Courtesy of the Snohomish Historical Society.)

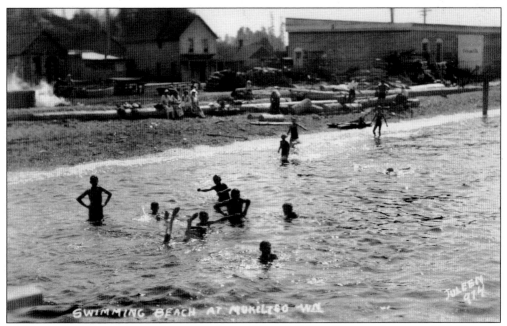

This area was often referred to as "McConnell Beach." The Peterson house and McConnell Boathouse are in the background. The photograph portrays swimming attire in the 1940s. (Courtesy of the Mukilteo Historical Society.)

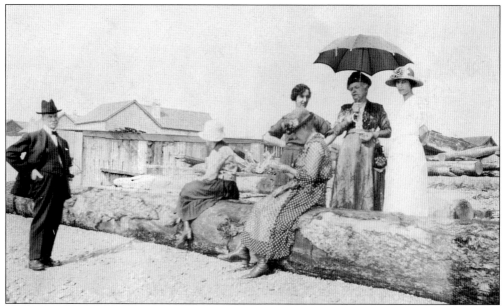

According to Madeline V. (LaBeau) Kuykendahl, "In the early morning, at low tide, the Japanese would walk the sandy beach in Mukilteo and gather seaweed that washed ashore. Then they'd carry it home, cut it into strips, dip it in caramelized sugar and sesame seeds, dry it on their fences, and eat it like candy." (Courtesy of the Mukilteo Historical Society.)

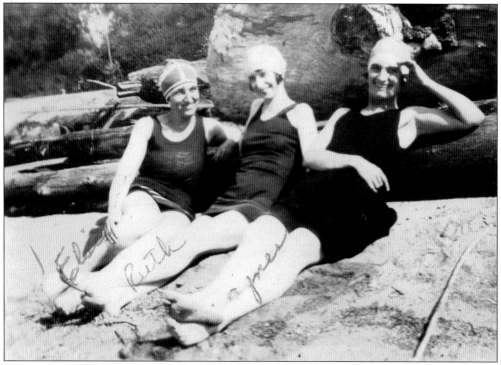

"We spent our childhoods on the beach, playing on logs, in sand, or swimming in Possession Sound," Marie (Josh) Kaiser (not pictured) reminisced. "My mother was always saying, 'Be careful of the drop off!' We had no idea of its depth!" (Courtesy of Renee Ripley.)

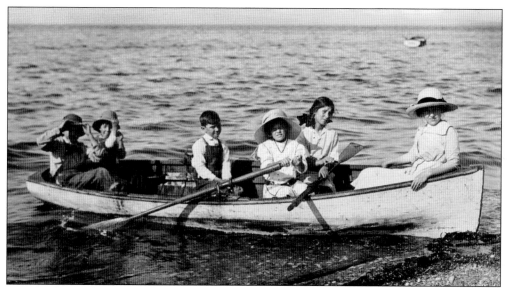

"Sometimes we'd row to Hat Island. We explored every inch of that place. It was our island. We'd build bonfires on the beach. We'd play until my father hung a white sheet on the roof of our house. That was our signal to come home," continued Marie (Josh) Kaiser. (Courtesy of the Mukilteo Historical Society.)

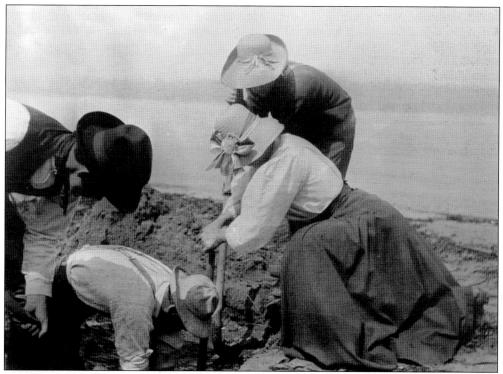

These folks are probably digging for geoducks. Unlike razor clams, one had to dig rather deep to find them. (Courtesy of the Snohomish County Museum of History.)

During the summer, when the mill closed for the day, people hurried home and ate dinner. Then they would walk down to the waterfront and congregate on the beach. (Courtesy of Marie [Josh] Kaiser.)

"When we were kids . . . our days were spent at the beach. It was a magical place to grow up," Madeline V. (LaBeau) Kuykendahl recalled. (Courtesy of Renee Ripley.)

Paul and Hannah Losvar emigrated from Norway to Michigan in the 1880s. Hannah died in Michigan after three children were born. Paul remarried and brought his family to Mukilteo in 1905. Paul Losvar went into the boat business. For 60 years and three generations, his family operated the Mukilteo Boat House. It was here that the "Muk" boat was developed. Their boat, with its unique bow, is an adaptation of Norwegian design. Pictured is Paul Losvar and his grandson Art Losvar. (Courtesy of the Mukilteo Historical Society.)

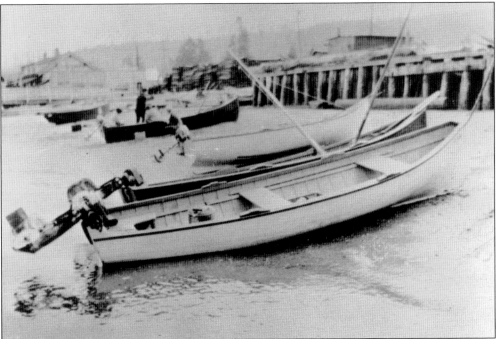

Besides wooden boats, the Losvars built commercial boats, tugboats, and boats for the navy. Over the years, this style has kept people dry and safe. In the 1930s, Paul's son George ran the business on Front Street. In those days, you could rent a 16-foot boat for $2 a day. Grandsons Art and Albert continued the Mukilteo boat tradition. (Courtesy of the Mukilteo Historical Society.)

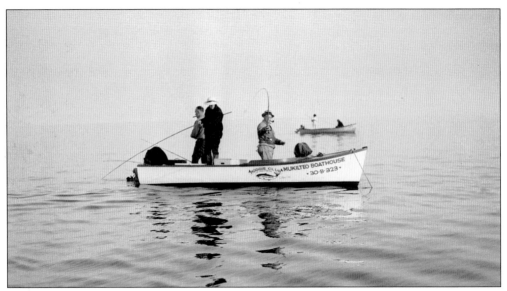

Each spring, on the opening day of fishing, the Sportsman Club of Mukilteo would host the annual fishing derby. The local boathouses did a booming business. They would check the engines, load boats with bait, tackle, and fishing poles, and then launch them into Possession Sound. By dawn, the bay would be crowded with fishermen. (Courtesy of the Mukilteo Historical Society.)

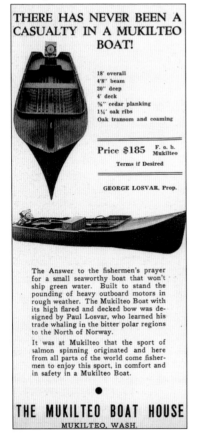

The Losvars produced 12-foot "clinker" or lapstrake rowboats. These stable boats were rented to local fishermen. By 1924, the Losvars began building larger boats. Some of these were 16 feet long. (Courtesy of the Mukilteo Historical Society.)

Paul Losvar's son George fell in love with the lighthouse keeper's daughter Anna Christiansen. They married in 1910. For the next 60 years, the family ran the Losvar Boat House next to the lighthouse. (Courtesy of the Mukilteo Historical Society.)

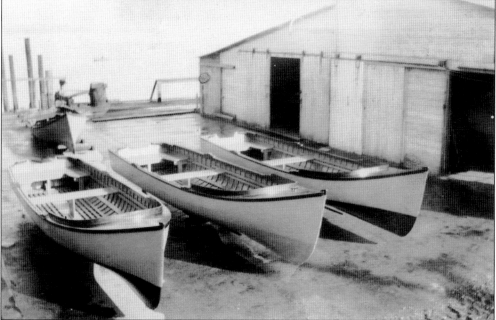

The "Mukilteo boats" were designed to handle larger motors. They were handmade with cedar planking and round bottoms. After 1939, the Losvars began selling their boats. Possession Sound had become a popular fishing spot. The last round-bottom Mukilteo boat was built in 1951. (Courtesy of the Mukilteo Historical Society.)

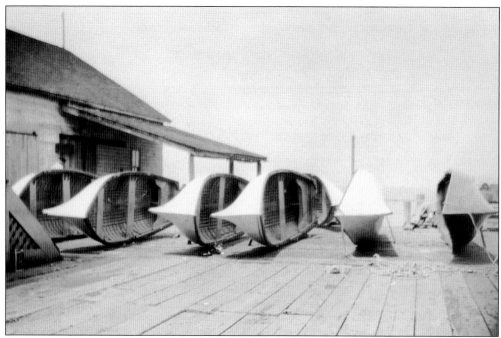

The acclaimed Mukilteo boats were built at the Losvars Boat House (pictured here). Boats were turned on their sides to be washed out when they came in from a day of fishing. (Courtesy of the Mukilteo Historical Society.)

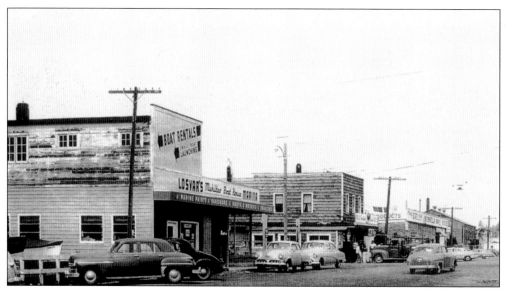

The Losvars Mukilteo Boathouse was well known. Celebrities used to visit for the fishing: one notable entertainer who visited Mukilteo was Bing Crosby. (Courtesy of the Mukilteo Historical Society.)

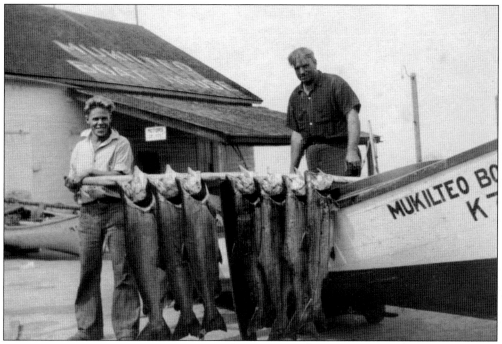

After a day of fishing in Possession Sound, Lawrence "Bumps" Hurd and his uncle Charlie Hurd display their catch of salmon, at the Losvar Mukilteo Boathouse in the 1930s. (Courtesy of the Mukilteo Historical Society.)

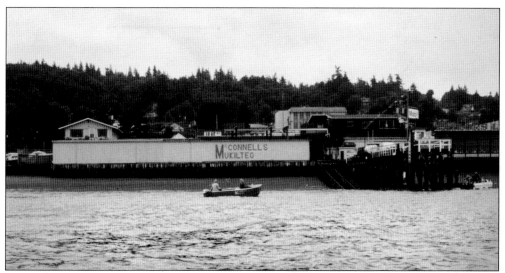

George McConnell came to Mukilteo after serving in the army during World War II. He was interested in starting a water-related business and was pleasantly surprised to find a waterfront building in Mukilteo with the name McConnell already printed on it. Victor McConnell, who was of no relation to George, had constructed the building in 1925. Mukilteo's first McConnell stored boats in the building and other items that Victor used in his service station on Front Street. (Courtesy of the Mukilteo Historical Society.)

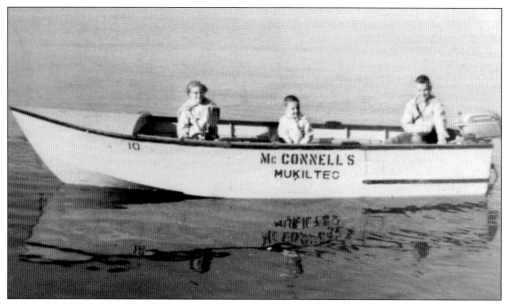

George McConnell bought the structure on May 1, 1946, and began building an equipped track so that rented boats could be launched from the facility. This structure was known as the McConnell Boathouse. In addition to boat rental and storage, the business handled bait and seining for herring and candlefish. With increasing numbers of people purchasing boats, the demand for storage space was strong. At one time, 17 boathouses existed between Edmonds and Kayak Point. Pictured above are the McConnell children, from left to right, Betsy, Brad, and Bruce. (Courtesy of the Mukilteo Historical Society.)

This is a picture of George and Opal McConnell shortly after they married. Opal was a bride when she moved to Mukilteo. She had a natural curiosity about people, and it didn't take long before she was writing about events in the community. Opal's book *Mukilteo: Pictures and Memories* portrays early life in Mukilteo. (Courtesy of the Mukilteo Historical Society.)

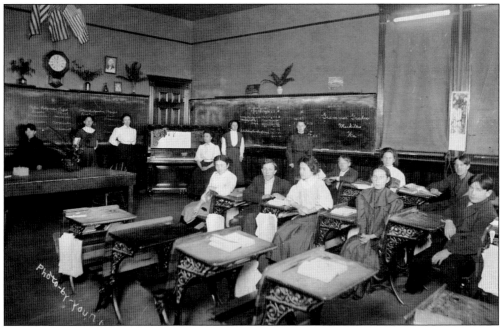

There were many expectations attached to a teacher's contract between 1915 and 1923. A few rules teachers were expected to adhere to included not smoking or drinking wine, beer, or whisky, wearing bright colors, dying one's hair,; wearing mascara or face powder, or painting one's lips. If a woman was single, she was not allowed to marry. They also could not keep the company of men, loiter in the ice cream parlor, or be seen riding in a carriage or automobile with a man, unless he was a relative. Violation of these rules meant one's contract was null and void. (Courtesy of the Mukilteo Historical Society.)

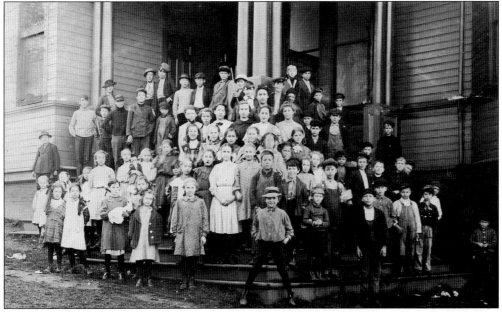

This photograph shows Rosehill School's class of 1907. Standing in front with his hands in his pockets is Cecil Haynes. (Courtesy of the Mukilteo Historical Society.)

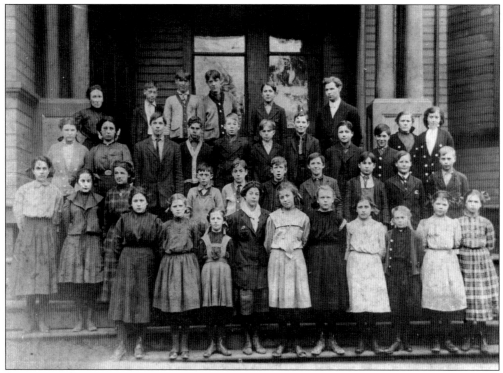

"My class made posters using the marine theme of boats and ships, in which most were familiar, since their parents worked near or on the water," Mary Lou Morrow said. "The four-masted schooners were a fascinating sight to see, moored in the deep harbor while they loaded lumber from the Crown Lumber Company mill." (Courtesy of the Mukilteo Historical Society.)

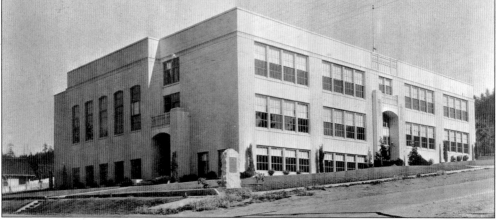

After the first Rose Hill School burned down, the Mukilteo School Board quickly approved plans to spend $65,000 for a new two-story building with 10 rooms, a basement, and combination gymnasium/auditorium on March 24, 1928. The building would be made largely from fire-resistant materials such as concrete. Architect Early Morrison designed the new Rosehill School (changed to one word). "We are planning a building that will meet the needs of the future," said Rosehill School principal Erwin Black and Snohomish County superintendent of schools W. F. Martin. Taking less than a year to build, the new school opened on September 12, 1928. (Courtesy of the Mukilteo Historical Society.)

Eight

PROHIBITION

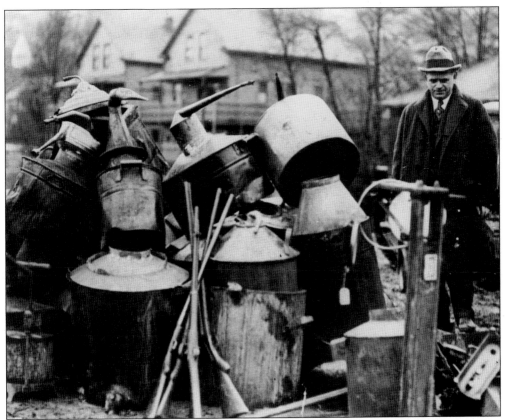

On December 31, 1915, the State of Washington allowed the sale of liquor until midnight, at which time Prohibition began. Residents had long supported making the sale or consumption of booze unlawful. Most residents also supported the National Prohibition Act, also known as the Volstead Act of 1920; however, not all Americans shared this opinion. Consequently, rumrunning and bootlegging suddenly became very popular and profitable. (Courtesy of the University of Washington.)

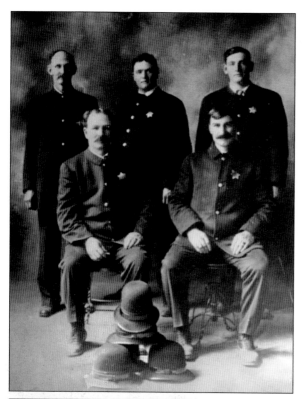

Local and federal law enforcement were responsible for apprehending criminals who violated the Volstead Act. Unfortunately, bootleggers and rumrunners were often regarded as folk heroes. Also, a large number of police officers were able to supplement their income during the Depression by simply turning a blind eye to the manufacturing, transportation, and sale of alcohol. (Courtesy of the Snohomish Historical Society.)

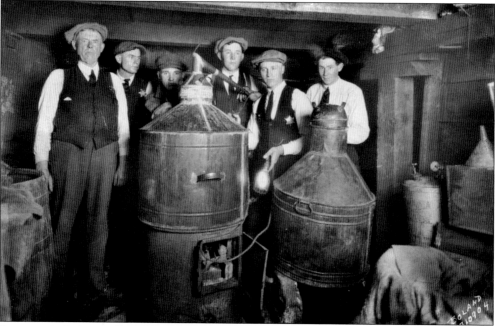

Because alcohol was allowed for religious and medicinal purposes, orders for sacramental wine (for church services) and prescriptions for alcohol skyrocketed during Prohibition. Journalist H. L. Mencken described the business of ignoring Prohibition laws as a "national sport." (Courtesy of the Everett Public Library.)

Around 1830, temperance organizations began promoting abstinence (versus moderation) from alcohol as the remedy for drunkenness. Women became quite involved in addressing alcohol abstinence. They formed organizations like the Women's Christian Temperance Union (WCTU), and through education, and social and political methods, they influenced the enactment of 1920s Prohibition. (Courtesy of the Everett Public Library.)

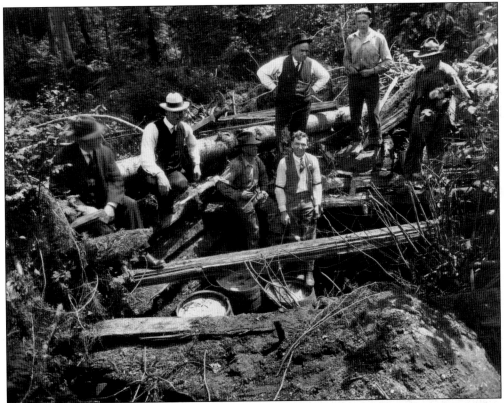

"Bootlegging flourished in the vicinity. Stills, and apparatus for distilling liquids used in making alcohol, were located in a carefully concealed rendezvous adjacent to the beach. Other stills were found, not so carefully concealed. The business flourished because there was a great demand for the product and it was a lucrative occupation during the Prohibition days," said Mary Lou Morrow. (Courtesy of the University of Washington.)

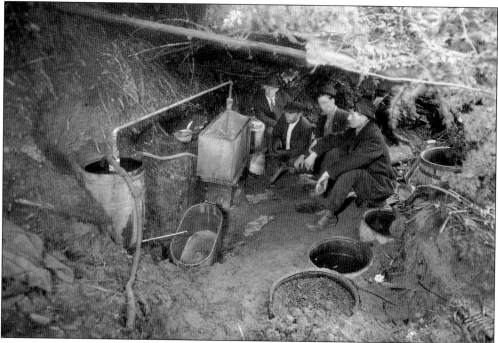

A resident who wishes to remain anonymous revealed, "While the town folk went to church on Sundays, we delivered booze under the mattress of our baby carriage to neighbors." (Courtesy of the Everett Public Library.)

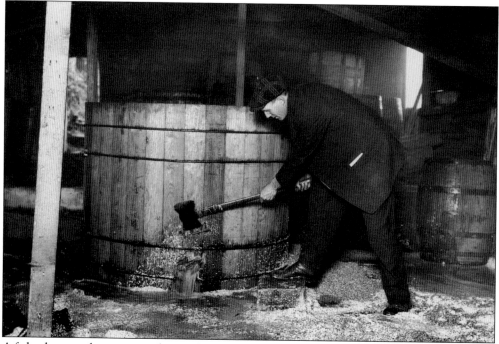

A federal agent takes an ax to a large still hidden inside a warehouse in Snohomish County. Besides homemade brew and moonshine whiskey, booze could often be purchased from some of the ships that loaded lumber at Crown Lumber Company. (Courtesy of the Everett Public Library.)

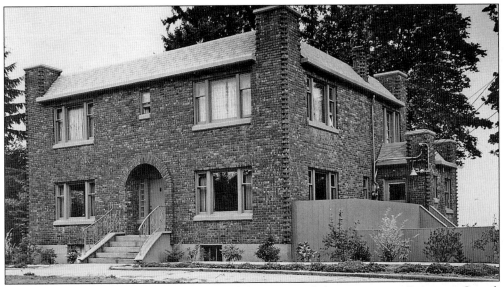

In 1929, a brick estate was built south of Mukilteo. Located above a cove on Possession Sound, the mansion was financed by Al Capone and associates. The owner was C. P. Richards. In reality, the home was a speakeasy and distillery, and Richards was a rumrunner. He installed a second basement in the two-story house that hid a still. A large, fake furnace blocked the entrance to the phony basement, and a secret tunnel connected the operation to the nearby gully. Under the canopy of trees in Smuggler's Gulch, bootleggers and rumrunners transported booze to and from Naketa Beach at night. The likes of "Short Card Johnson" and "Charlie the Pup" shipped illegal liquor around Puget Sound. In 1931, federal agents arrested C. P. Richards when his still caught fire and drew the attention of local authorities. Today it is the site of Charles at Smuggler's Cove Restaurant. (Courtesy of the Everett Public Library.)

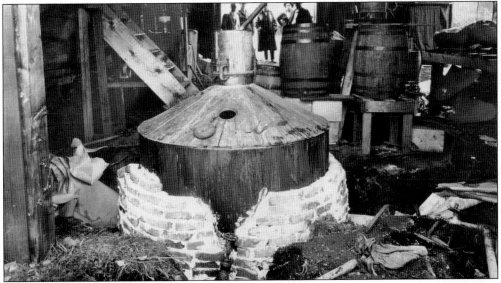

During Prohibition, moonshine was also called "hooch" and "white lightning." The homemade whiskey or alcohol got its name from producers who worked under the cover of moonshine. Though they were called rumrunners, most of the booze in Mukilteo was Canadian whiskey. (Courtesy of the Everett Public Library.)

Roy Olmstead was a lieutenant with the Seattle Police Department in 1920; however, he was dismissed after being caught smuggling booze. This didn't stop Olmstead. By 1924, he was running the largest liquor smuggling operation in Western Washington. Known as the "Honest Bootlegger," because he never cut or diluted his liquor, Olmstead became a folk hero. His men did not carry guns, as Olmstead abhorred violence. "Nothing we do is worth a human life," he would lecture his men. Prior to his arrest on November 17, 1924, Olmstead employed 50 people and grossed $200,000 a month. Even city officials and police officers were in his pocket. Seen above is Olmstead with his wife, Elsie. (Courtesy of the University of Washington.)

Nine

PUGET SOUND AND ALASKA POWDER COMPANY

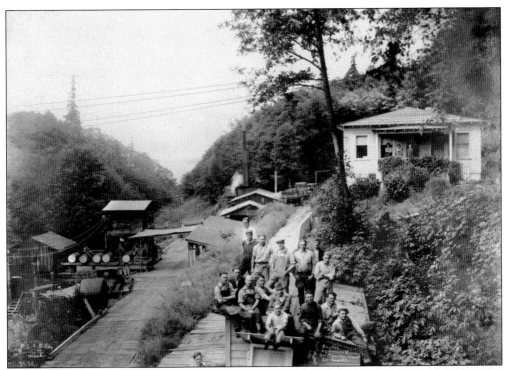

In 1906, the Puget Sound and Alaska Powder Company established a plant near Mukilteo. The company manufactured dynamite. They produced about 400,000 pounds a month. The dynamite was used for logging, railroad work, and clearing land, and gelatin dynamite was used for mining. It was shipped to Alaska, Canada, California, Montana, and Idaho. Peter David owned the plant. (Courtesy of the Everett Public Library.)

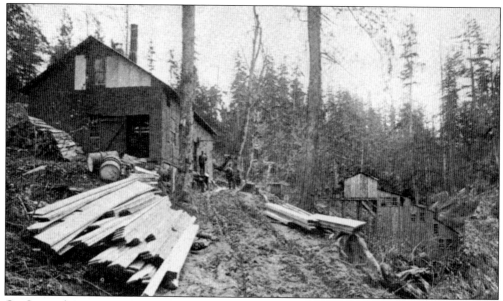

On September 17, 1930, a few minutes before 6:00 p.m., two explosions shook the communities of Mukilteo and Everett when the Puget Sound and Alaska Powder Company blew up. (Courtesy of the Everett Public Library.)

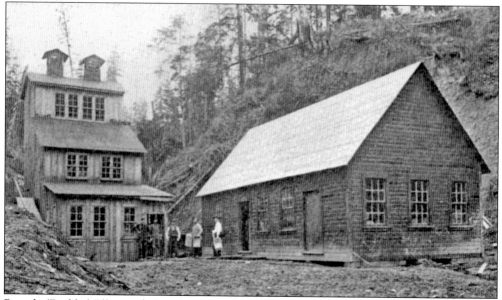

Beverly (Dudder) Ellis remembered, "I was up at the neighbor's house, when I heard a boom and the ground started shaking. I looked up in the sky and there was a huge mushroom cloud of smoke. I dropped my pail of apples and ran for home!" (Courtesy of the Mukilteo Historical Society.)

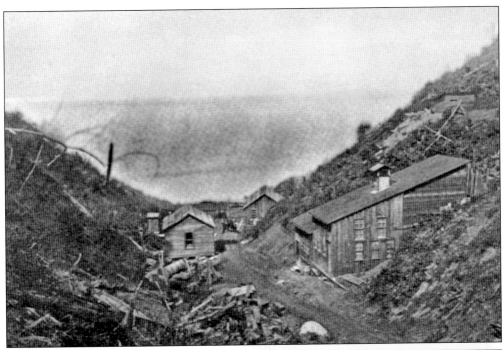

The gunpowder plant, located in a gully about a mile and a half northeast of Mukilteo and 4 miles southwest of Everett, was completely destroyed. Luckily, there were no deaths. (Courtesy of the Everett Public Library.)

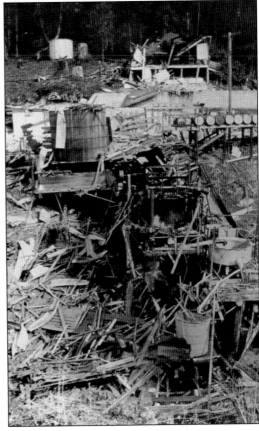

The explosion was felt as far away as downtown Everett. The impact shattered windows, and eight residents were injured from broken glass. (Courtesy of the Everett Public Library.)

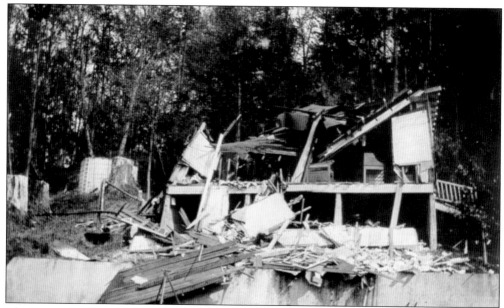

The fire at the Puget Sound and Alaska Powder Company began when a spark ignited waste in the ammonium-drying house. When it reached the nitroglycerin house, it exploded. The first blast involved 6,000 cases of dynamite and 6,000 pounds of nitroglycerin. It was one of the largest explosions that has ever occurred near a populated community. (Courtesy of the Everett Public Library.)

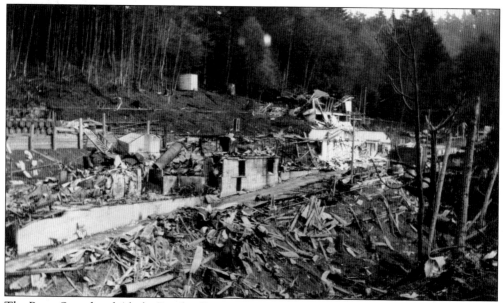

The Puget Sound and Alaska Powder Company was one of two gunpowder plants in Snohomish County. It employed 30–40 men. Damage was estimated at $250,000, and the plant was never rebuilt. (Courtesy of the Everett Public Library.)

Ten

PIONEER CEMETERY

Mukilteo's Pioneer Cemetery is located at Fifth and Webster Streets. Situated on a bluff, the property offers picturesque views of Whidbey Island and Possession Sound. It dates back to the days of Mukilteo's founder, Morris H. Frost. Mukilteo's other founder, Jacob D. Fowler, buried his brother Capt. Nathaniel B. Fowler on this property. Morris H. Frost may have designated this part of his property as a cemetery. (Author's collection.)

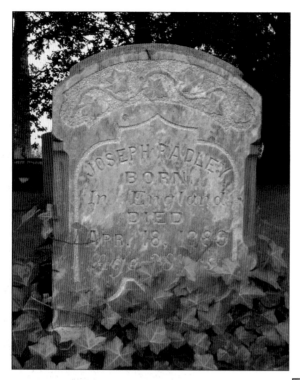

Later in his life, Frost fell into debt, and much of his property went into receivership. Around 1890, Louis and Emma Church purchased the property. Their intentions were to continue to use the land as a cemetery; however, they did not follow through on this formality. Instead, a residential neighborhood grew up around the abandoned cemetery, with no burials after 1920. (Author's collection.)

During the Depression, the cemetery was vandalized. Alice Pallas Brooks, one of the town's early teachers, described the damage in Opal McConnell's book *Mukilteo: Pictures and Memories.* "Fences were all removed and the markers knocked down. Some were broken and some are lost. My father with the aid of a friend mended and remounted them. Mr. Frost's marker was broken into two pieces . . . As a result of this devastation, several grave sites are completely lost." (Author's collection.)

The cemetery includes the markers of three Japanese employees of Crown Lumber Company. Mas Odoi of the Mukilteo Historical Society translated the markers of Goro Wadatani, Tokumatsu Shirai, and Rikimatsu Okamura. Because people buried in the Pioneer Cemetery came from far away places to Mukilteo, finding information about them presents a challenge. (Courtesy of the Mukilteo Historical Society.)

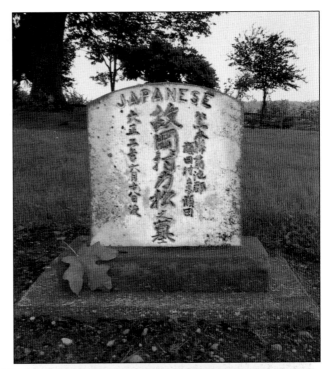

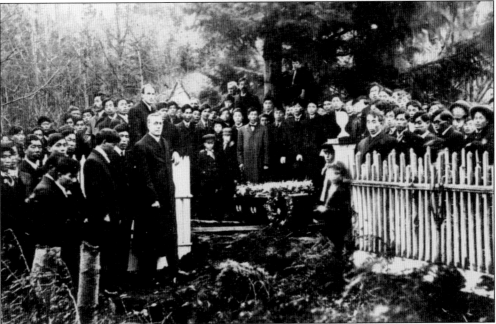

The original source for names of those buried in the Pioneer Cemetery appears to be a handwritten list provided by Louisa Fowler Sinclair, daughter of Jacob Fowler and niece of Nathaniel Fowler. The cemetery is arranged in seven rows. Today the number of marked graves totals 43 and includes a melting pot of early pioneers including the Indian chiefs, shipbuilders, woodmen, soldiers, and immigrants who helped settle early Mukilteo. The above picture shows a Japanese funeral at the Pioneer Cemetery in 1909. (Courtesy of the Mukilteo Historical Society.)

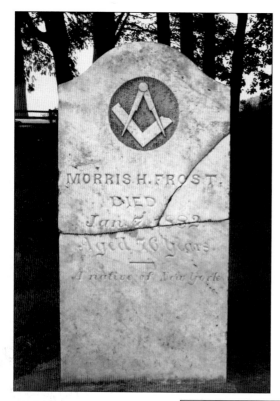

Morris H. Frost, whose gravestone is etched with the Masonic emblem, never lived to see statehood for Washington Territory. Active in politics throughout his life, Frost was a member of the first board of county commissioners and a delegate to the territorial legislature. Prior to moving to the Northwest, Frost lived in Chicago. At the time, it was just a village. His partnership with Fowler proved a good business venture. Frost died in Mukilteo on January 7, 1882. (Author's collection.)

Jacob D. Fowler's headstone reads, "Born Dec. 14, 1837 Died Aug. 24, 1892 (age 55) J. D. Fowler, pioneer, established a trading post and named it Mukilteo, an Indian word for 'Good Camping Ground.' He was head of the first family and with Morris H. Frost, his partner, claimd [sic] as homestead the original area of the Town of Mukilteo. He was the first Co. Auditor, first Judge, first Mukilteo Postmaster and first Notary Public. This plaque erected 1982 by the Mukilteo Historical Society." The Pioneer Cemetery was placed on the Washington Heritage Register in 1973. (Author's collection.)

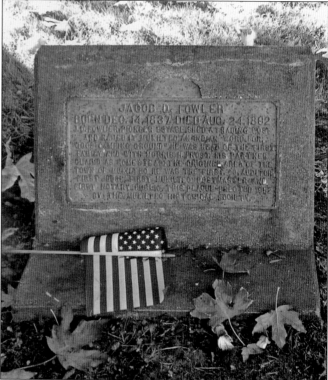

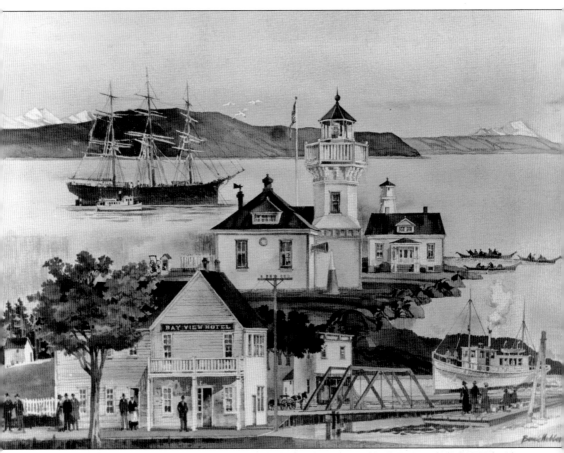

Mukilteo was incorporated in 1947, and the city's first mayor was Alfred Tunem (1896–1972). At the time, Mukilteo's population was only 775, but progress had begun. An air force fuel storage facility known as the "Tank Farm" was built in 1951 and existed where Crown Lumber Company once stood. The Great Northern Railway line ran along the waterfront, and ferry service was in operation to Whidbey Island. Who would have thought that in 150 years Mukilteo would go from a small trading post with a handful of settlers to a thriving economic community with a population of 20,742. This painting by local artist Bernie Webber, nephew of Arne R. Jensen, depicts early Mukilteo. (Courtesy of the Mukilteo Historical Society.)

www.arcadiapublishing.com

Discover books about the town where you grew up, the cities where your friends and families live, the town where your parents met, or even that retirement spot you've been dreaming about. Our Web site provides history lovers with exclusive deals, advanced notification about new titles, e-mail alerts of author events, and much more.

Arcadia Publishing, the leading local history publisher in the United States, is committed to making history accessible and meaningful through publishing books that celebrate and preserve the heritage of America's people and places. Consistent with our mission to preserve history on a local level, this book was printed in South Carolina on American-made paper and manufactured entirely in the United States.

This book carries the accredited Forest Stewardship Council (FSC) label and is printed on 100 percent FSC-certified paper. Products carrying the FSC label are independently certified to assure consumers that they come from forests that are managed to meet the social, economic, and ecological needs of present and future generations.

FSC
Mixed Sources
Product group from well-managed forests and other controlled sources

Cert no. SW-COC-001530
www.fsc.org
© 1996 Forest Stewardship Council

Find Your Place in History.